Montero

"Certainty makes the painter.
Uncertainty makes the artist."

Matthew Montero

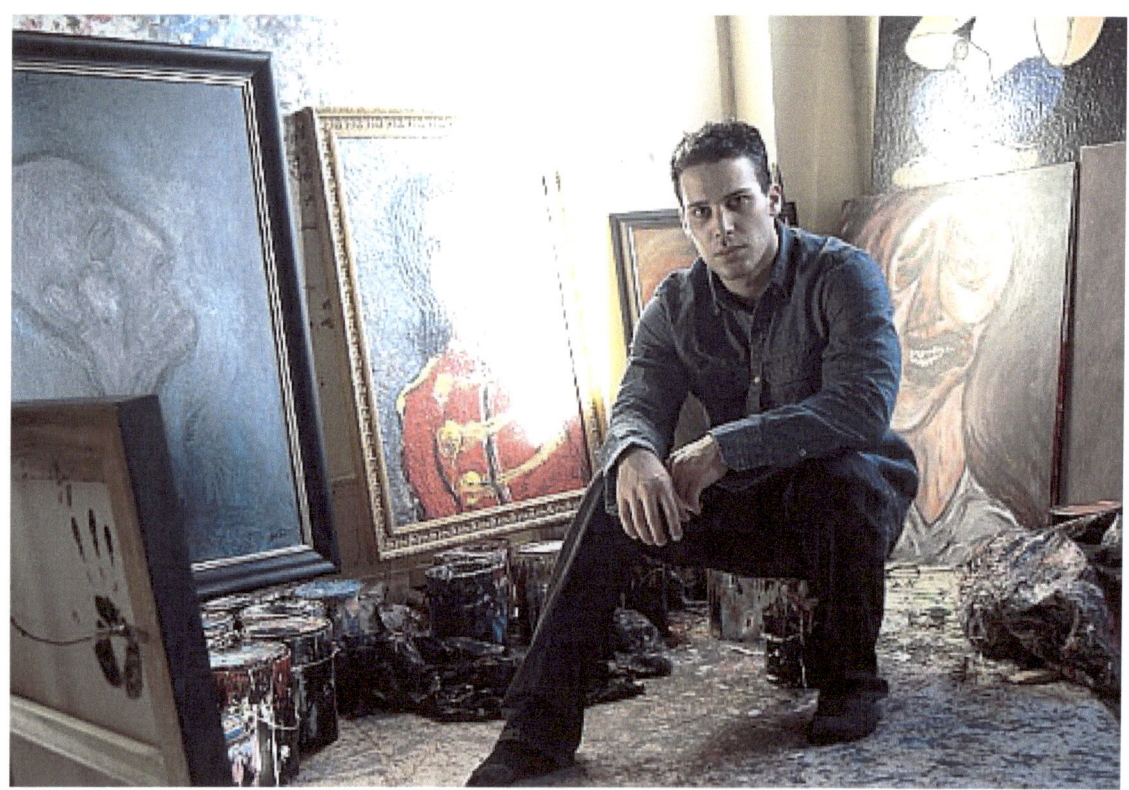
Montero in his studio, 2013. Photograph by Michael Cruz.

MONTERO

The Strength of Conveyance

David Leonard

COVER:

The Indulgence
Oil on canvas, 36 x 36 in.
91.4 x 91.4 cm

Lulu Publishing 2013. www.lulu.com

Project Director: Alison Ashe

Text Editor: Jamie Leblanc

Picture Editor: Seth Roberts

MONTERO: The Strength of Conveyance

Text copyright © David Leonard and Matthew Montero
All images are © copyright and property of their respective owners

All rights reserved. No portion of this book may be reproduced by any means. Including everything from mechanical, electronic, photocopying, recording, or otherwise, without prior permission in writing from the publisher. This catalogue was done in collaboration with the artist, and has been approved by the artist.

Printed and bound in the United States of America

please visit: **www.monteroart.com**

Contents

1

Introduction

3

The Artist Within

9

Selected Works

47

Acknowledgements

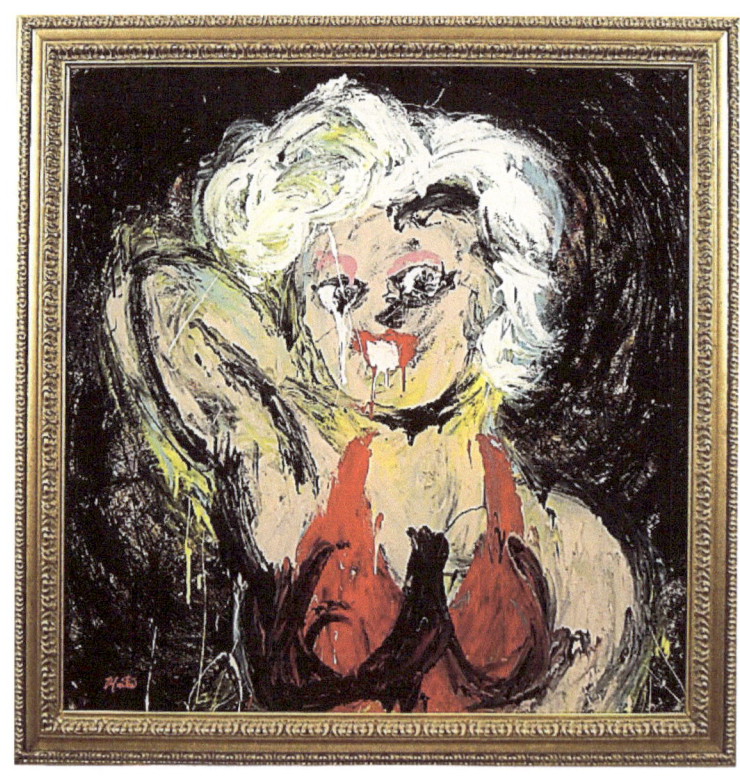

Marilyn | Oil on canvas, 36 x 36 in. | Private Collection (China)

Introduction

His paintings have an unmistakable presence. Not because they are big, not because they are flashy, but because they carry with them such a force, such a genuine power and substance, that a single painting of his can own an entire room. His name is "Montero". And he is an artist who is deeply invested in the raw, physical creation of a painting. Working solely with his hands and raw house paint, he slathers, transforms, and assails the canvas with the most forceful and delicate of strokes. This complete investment of self in his work is what makes the images so authentic. We can literally feel him in every painting. His soul bleeds into every smudge, his intensity vibrates in every stroke, and his passion is reflected in every subject. This input, combined with the absolute strength of his images, is nothing short of refreshing – like a breath of much needed fresh air. Inevitably, what it all represents, what it all amounts to, is a strong and thorough artistic vision.

The Artist Within

Searching from the Beginning

Born Matthew John Montero on June 22, 1988 in Covington, Louisiana to Martha and Lloyd Montero he was, from the beginning, an eccentric personality. Fascinated by people like Oscar Wilde, Marlon Brando, Pablo Picasso, Ludwig van Beethoven, Sigmund Freud, Mike Tyson, and Lord Byron, he was instinctively drawn to turbulent individuals. Like them he possessed an inner fire that drove him to excel. On the same token, he also had a destructive side that revealed itself often in explosive bouts of fury. For instance, when playing in a school basketball game he kicked the ball into the crowd out of frustration. Montero asserts, "The other team kept taking cheap shots at one of my teammates and I got so pissed off that I kicked the ball as hard as I could." He was immediately ejected from the game. His parents often worried about these violent outbursts. His father seriously considered sending him to military school, while his mother would take him to therapy sessions. His aggressive antics went as far back as kindergarten where he was reprimanded for biting another child at recess.

This difficult, and at times, disturbing behavior was difficult to manage among his childhood educators. He would frequently talk back to teachers, lie, say derogatory comments, steal, and not follow directions. "He had a violent temper" recalls one of his school principals, "but I

always sensed that something well intentioned was driving him." He also demonstrated an intense self-absorption early on. "For as long as I can remember I've been told I would be great at whatever I chose to focus on." This exaggerated sense of self would prove instrumental in Montero eventual flowering. For despite the negative aspects of his personality there was an extremely productive and ambitious side. He possessed an unusual talent in many fields — athletics, art, writing, acting. With such natural aptitude he found it difficult to focus in one area. His mother points out: "Every few months there was something new, some new idol, some new way of dressing. He was constantly reinventing himself. One day he would dress like a bohemian, the next he would put on a suit, you never knew he was going to do next."

Montero's fierce drive was embedded in his psyche from an early age. In his youth he felt compelled to compete and outperform his older brother Mark in games of basketball, wrestling, body building, and everything else. "Everyone in my family is very competitive. My cousins, my dad, my brother, we all want to win to a desperate level." This kind of upbringing instilled in him a rage to constantly perform. "It's not about being good. Good means, not good enough. It's about being great." Montero once said. These lofty standards allowed him to excel, particularly in the arts. In acting, he found a way of projecting his inner forces on stage. The result was a magnetic stage presence. It was a charisma that afforded him headlines in the school paper such as: "Montero kept the audience spellbound with his monologue." His drama

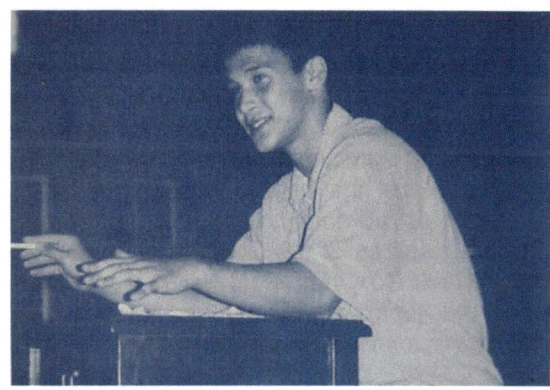

"Seventh grader, Matthew Montero, kept the audience spellbound with his monologue." 2001 Talent Show headline, Christ Episcopal School.

teacher recalls "you could hear a pin drop the silence was so palpable. He was that riveting to watch." Sensing acting was not for him he turned his heart to motivational speaking. "I got into Tony Robbins. I wanted

to do what he did. I wanted to reach people." He obsessed over motivational material such as Walt Disney's perseverance and Arnold Schwarzenegger. Feeling the spirit in him turning, he decided to deliver a motivational speech to the junior and senior classes.

Picture below: Montero's 2006 motivational speech at the St. Paul's School auditorium.

He asked permission from all the teachers to let the students attend his speech. They agreed and Montero delivered his speech to about 120 students and faculty. The outcome was admirable but not exactly touching for his fellow classmates. His confidence and conviction shined, but his overintensity proved to be too much for the young students to digest. The overall effect ended up being more intimidating than moving. Realizing that this was neither for him, he abandoned motivational speaking and search for a different way to preach. Even when he was a child this need to satisfy his own inner sense was tremendously important. He showed an unusual contempt for the rules at an early age. This frequently frustrated his art teachers

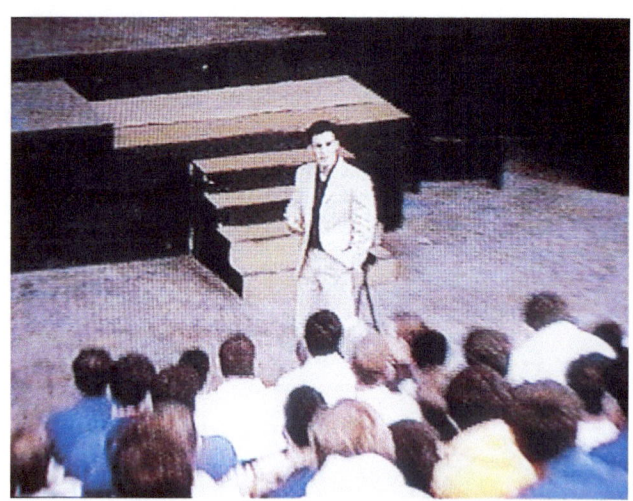

who insisted that he adhere to the "correct" techniques and guidelines. Despite their demands, Montero's faithfulness to his own vision would soon reward him. While in elementary school he drew a picture of a toucan that ended up being manufactured into refrigerator magnets and rugs that were sold nationally. Despite this early success, his artistic interest would shift as he grew older. In high school, he felt confined by the strict rules of academic art and opted to abandon art completely. It was not until his first semester in college that he would reunite with art. This time around, the results would be different. Without any instructors breathing down his neck, the manifestation of his strongest and deepest passions could now be realized. Montero proceeded to release an array of

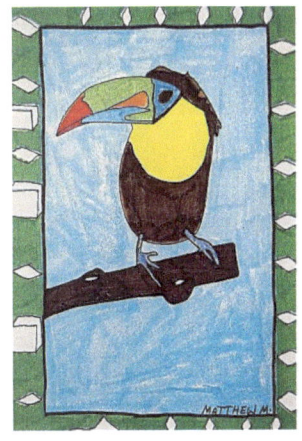

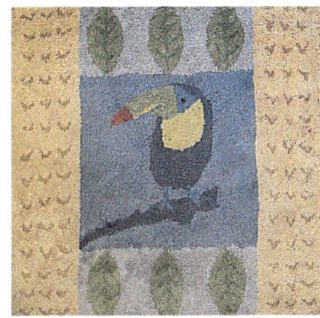

Middle: Bath Rug later popularized based on drawing.

Above: Montero's original childhood drawing of a Toucan.

powerful and deeply-held emotions. This purging was what he, and everyone else around him, had desperately been waiting for: something constructive and eloquent that he could pour all of his energy and conviction into. What emerged now was not just the skill, but the willpower. Those who remembered his raw potential now saw the result of what happens when passion and purpose meet.

Tracing the Roots

No matter how radical or unfamiliar an artist's work may seem, it nearly always stems from some borrowed source. Up to a point this is inevitable, much like a basketball player studies the moves of the previous generation and incorporates them into his repertoire; an artist studies the techniques and styles of past artists in an attempt to develop his own method. Jackson Pollock would have a particular influence early on in Montero's work. Works such as *Sitting Nude, Figure Faced with Death*, are all executed by tossing and heaving paint onto canvas. Today, Montero thinks of them as "early experiments". On the other hand, the influence that de Kooning provided would never leave his side. Many of his paintings carry with them a de Koonian like stroke – fast moving and pumping with energetic life. He states, "A painter must

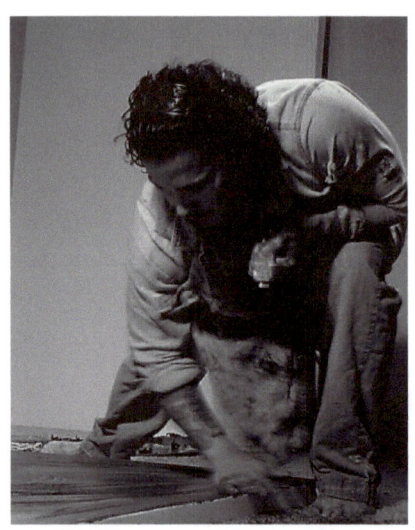

do more than just glance at history; he must incorporate it as much as possible, no painting falls from the sky."

"Hands Only"

Instead of operating with a brush, Montero uses only his bare hands to paint. Like a symphony conductor, he orchestrates his hands to and fro, rising and falling to the beat of his own inner thoughts and feelings. This poetic handling of paint allows his canvases to flow with the speed, grace, and power of a great sonnet. To Montero, it is all natural: "I've never felt comfortable with a brush. Using my hands just feels right." It is important to note that even though his images are painted with brawn, zest, and raw emotion, they do possess a marvelous intellectual substance and sophistication. The sheer volume of psychological content contained in many of these works makes them inexhaustible documents of the human mind.

"It's torture to paint" Montero says. This is a key revelation because it reveals that the very act of creating is grueling. The painter must imbue a blank white canvas with something inspiring and intense. In addition, he must confront, battle, and hope to overcome his demons in a process that does not always pan out. In fact, Montero claims, "In painting, there is no arrival; it's like a constant vacuum that needs to be filled. No matter how satisfying my last picture was I still feel no more confident going into the next one. There is constant insecurity, and that may just be it."

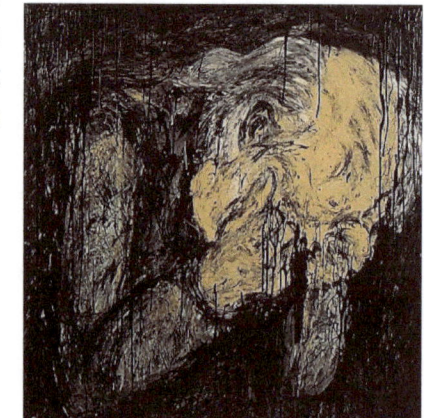

Above: Montero painting in his studio. Photo by Michael Cruz.

Right: | *Vincent* | Oil on canvas, 40 x 40 in. |

Emotion and Color

The language of color has entered our vocabulary to help us describe our emotions. You can be 'red' with rage or 'green' with unconscious desire. We often speak of bright cheerful colors as well as sad or dull ones. A 'grey' or 'blue' may be understood as a depressing or dreary state. Picasso, as well as countless of other expressionistic artists, have used color to express specific emotions and feelings. For instance, in Picasso's 'blue period' he used cool colors to evoke the chill of sadness and the weight of despair. Similarly, Vincent van Gogh, in his '*Sunflower*' still life's, used warm yellows to create an energetic image that radiates feelings of hope and joy.

Montero demonstrates the same kind of symbolic association with color. He uses reds, blacks, and oranges to convey violence, death, and anger, blues and grays to convey gloom, and greens, whites, and yellows to express joy and wisdom. The display of color in his paintings is generally subdued. They rarely, if ever, take center stage. His general distrust of solid hues prevents them from figuring too prominently in his compositions. "My paintings are not about color, they are about subject. When I choose a color it is always based on the relationship it has to the expression of the subject." Thus, his colors serve as amplifiers, complements that help give coherence to the overall conveyance.

It is important to illustrate how color is integrated in Montero's paintings. Different shades of pigments are blended and mixed into one another producing a gritty kind of display. This frenzied and densely layered application is comparable to the presentations of Willem de Kooning and Jasper Johns. Montero claims, "A painter's stroke should come as natural as breathing. It should never be forced or feigned." This harks back to notion that artists paint what they are. Under this assumption we should be able to tell everything about the artist (personality, attitudes, beliefs) based on his or her painting style. To a large extent, we can; Matisse's painted worlds apart from Pollock, Mondrian painted far different from Van Gogh, and so on and so forth. Ultimately, every real artist has reflected their unique temperament in their work.

Selected Works

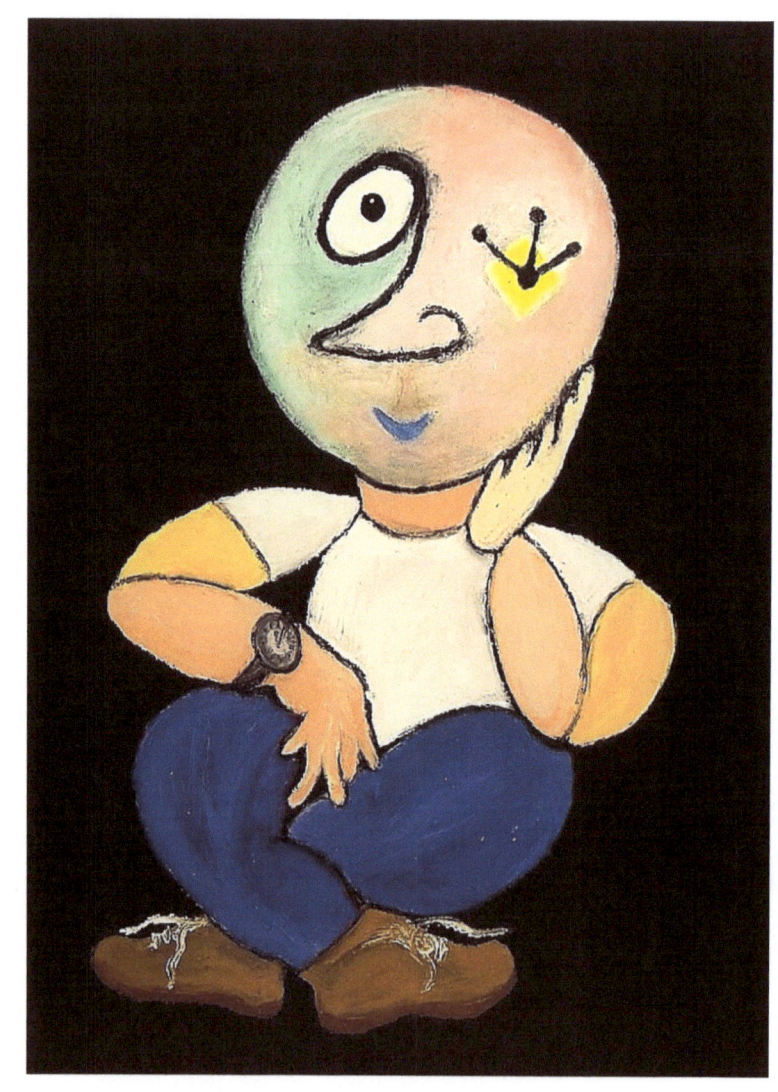

The Dreamer | Oil on canvas | 32 x 43 in.

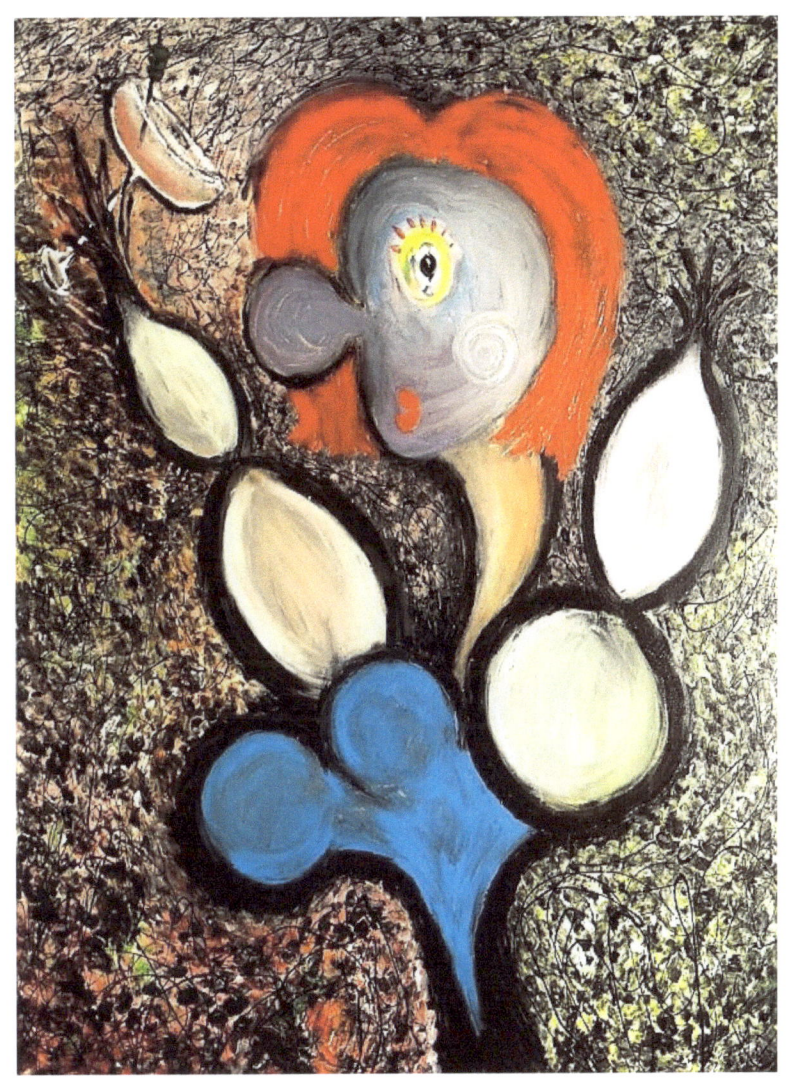

Girl with a Drink | Oil on canvas | 30 x 40 in.

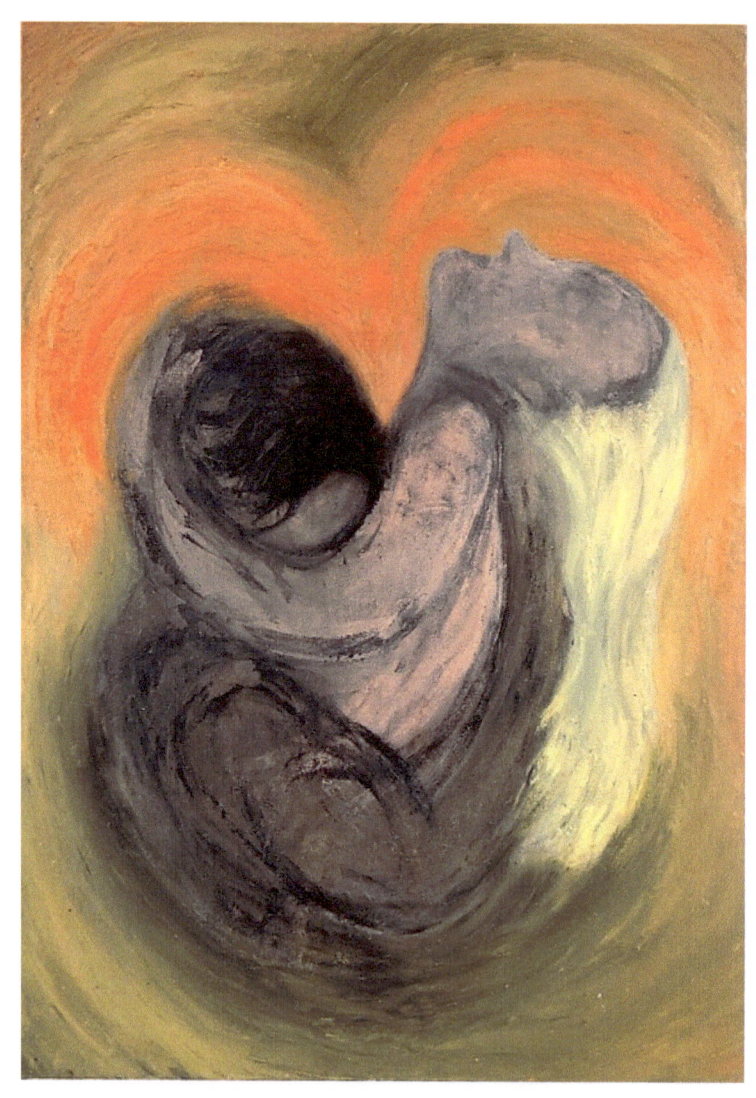

The Embrace | Oil on canvas | 24 x 30 in.

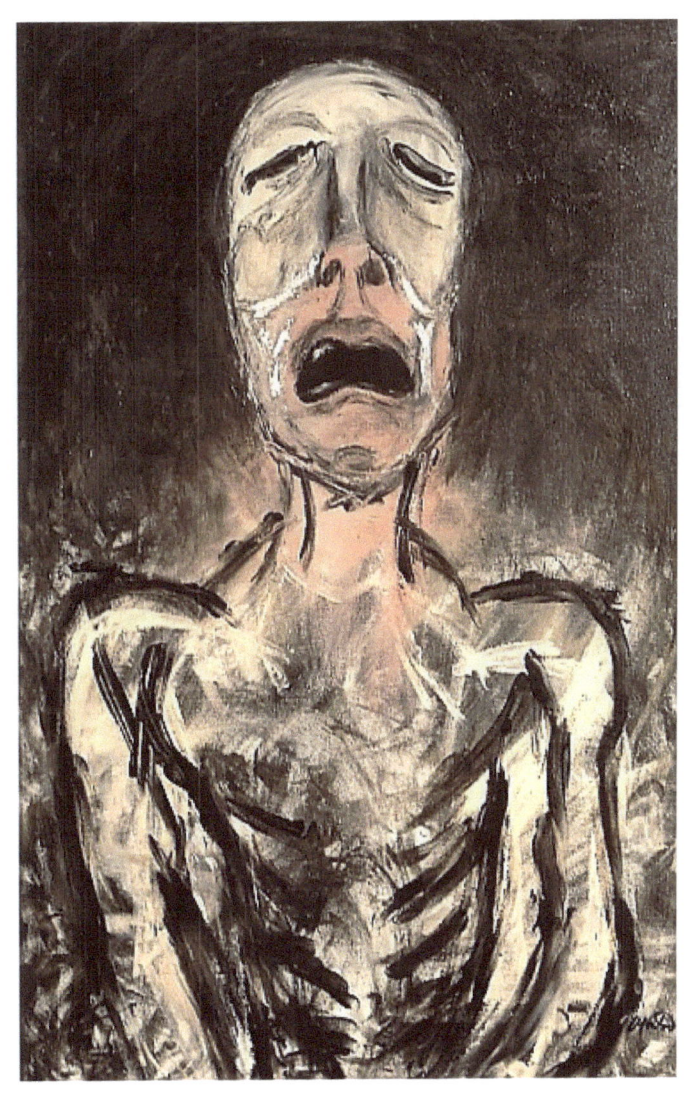

The Horror | Oil on canvas | 24 x 36 in.

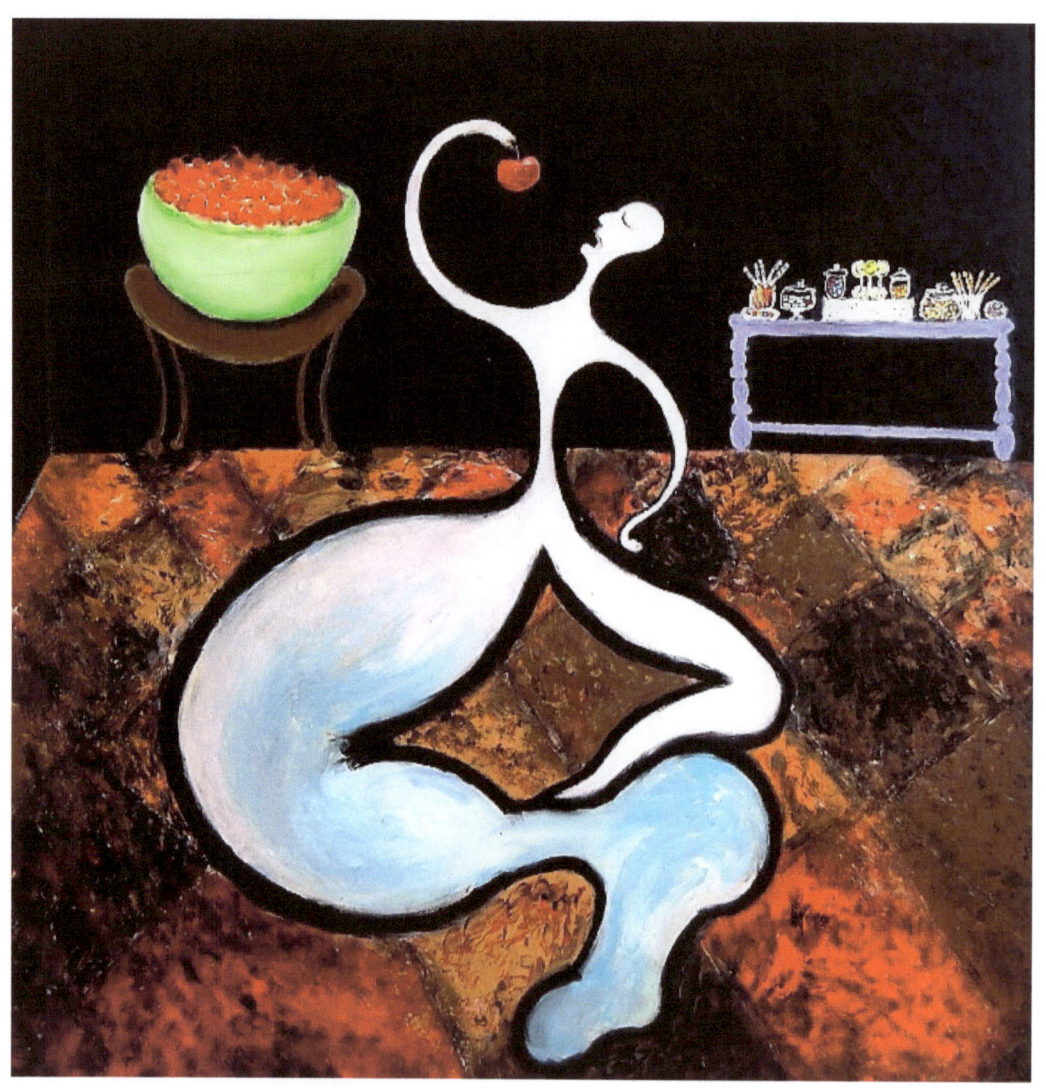

The Indulgence | Oil on canvas | 36 x 36 in.

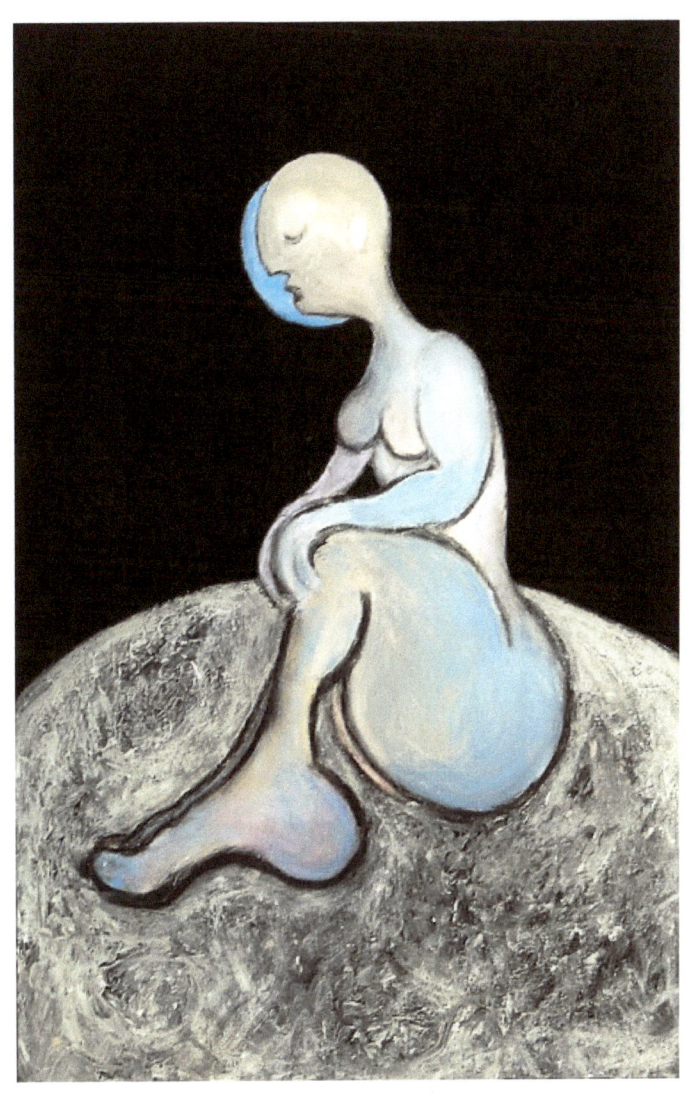

Sleeping with the Moon | Oil on canvas | 24 x 36 in.

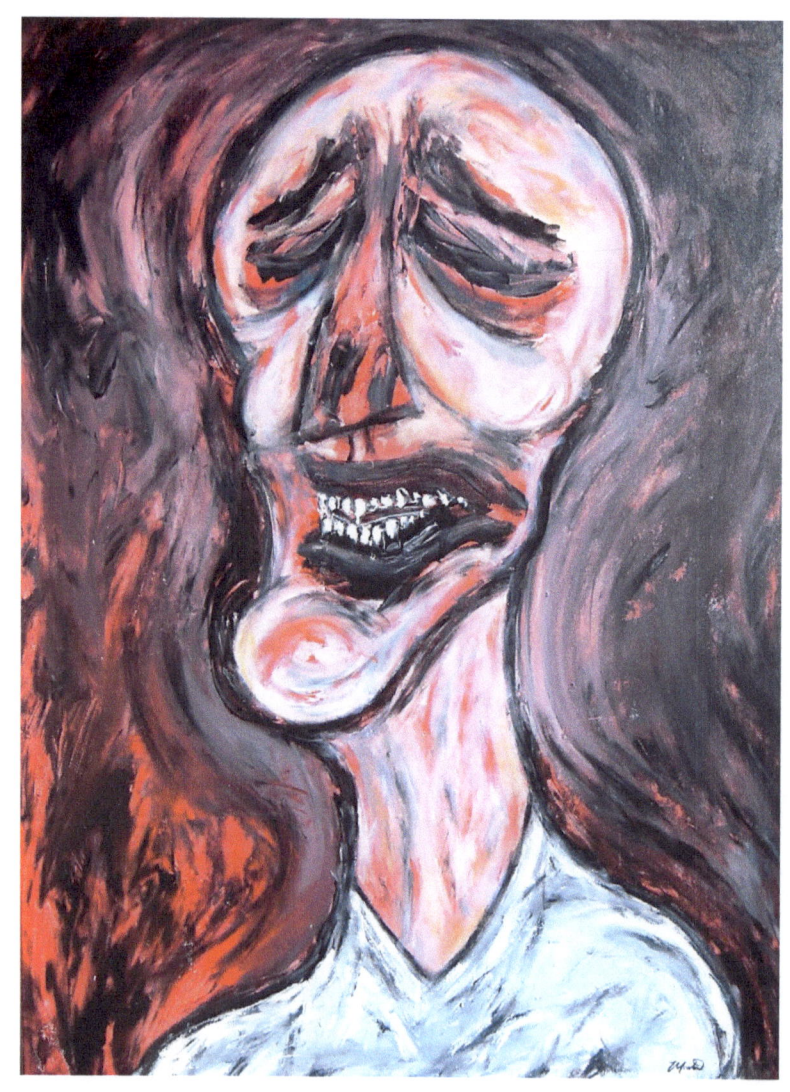

The Grind | Oil on canvas | 30 x 40 in.

Agony of the Soul | Oil on canvas | 30 x 48 in.

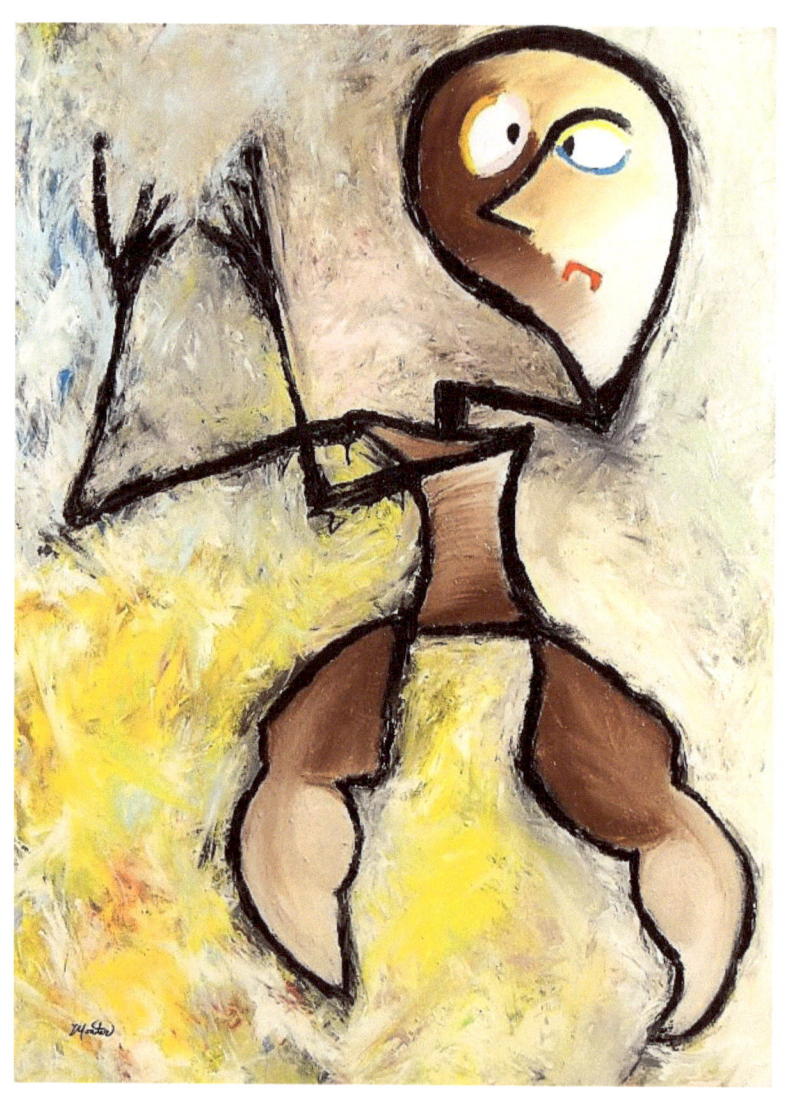

The Musician | Oil on canvas | 36 x 48 in.

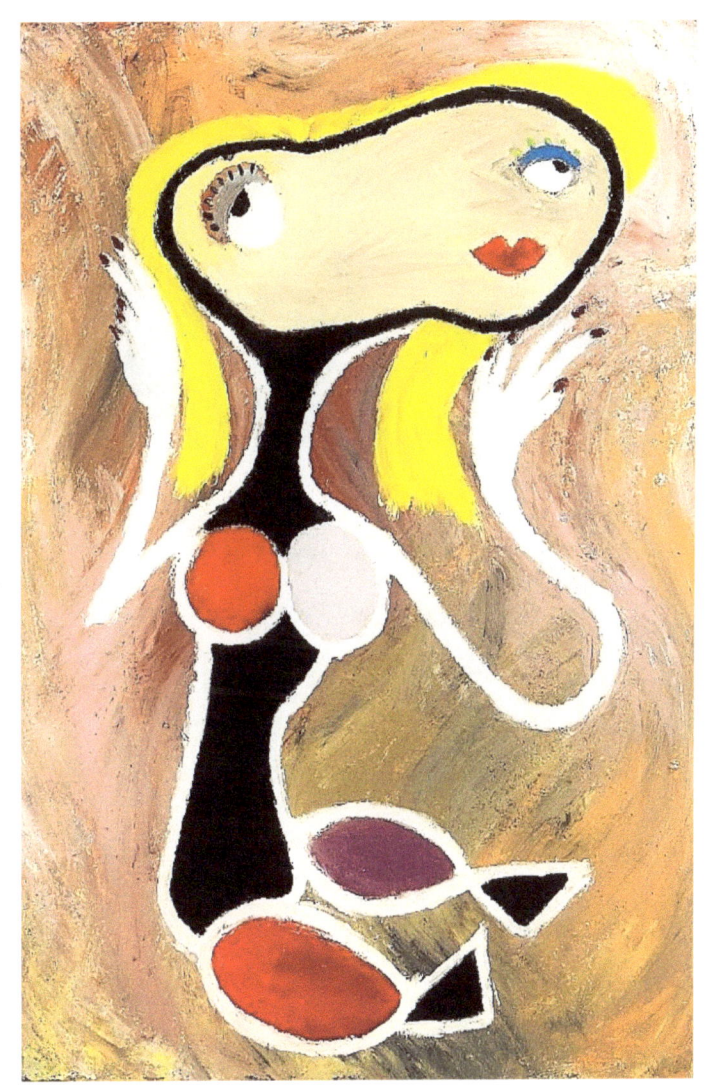

Vanity | Oil on canvas | 24 x 36 in.

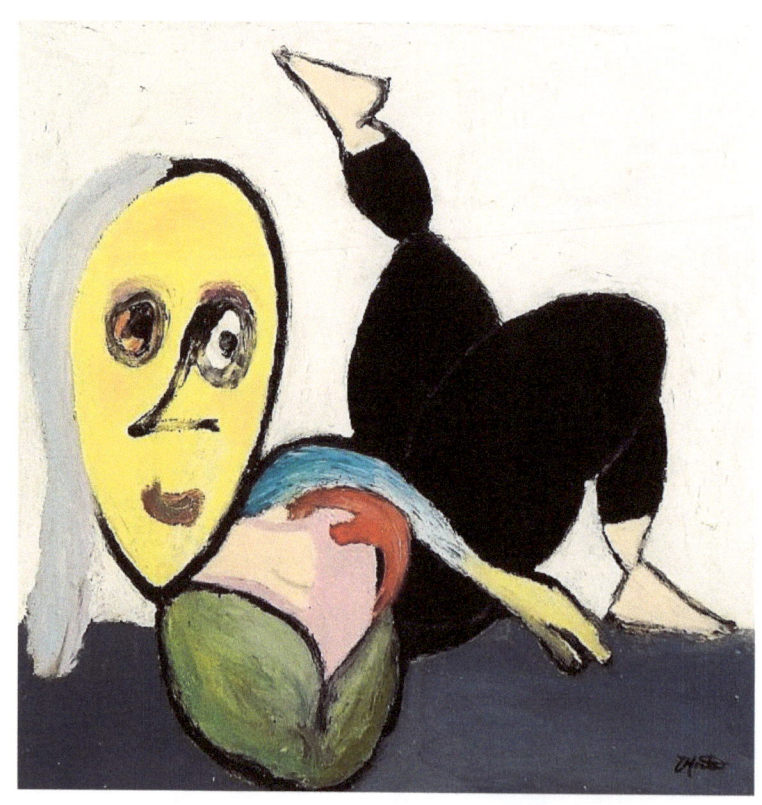

The Exercise | Oil on canvas | 24 x 24 in.

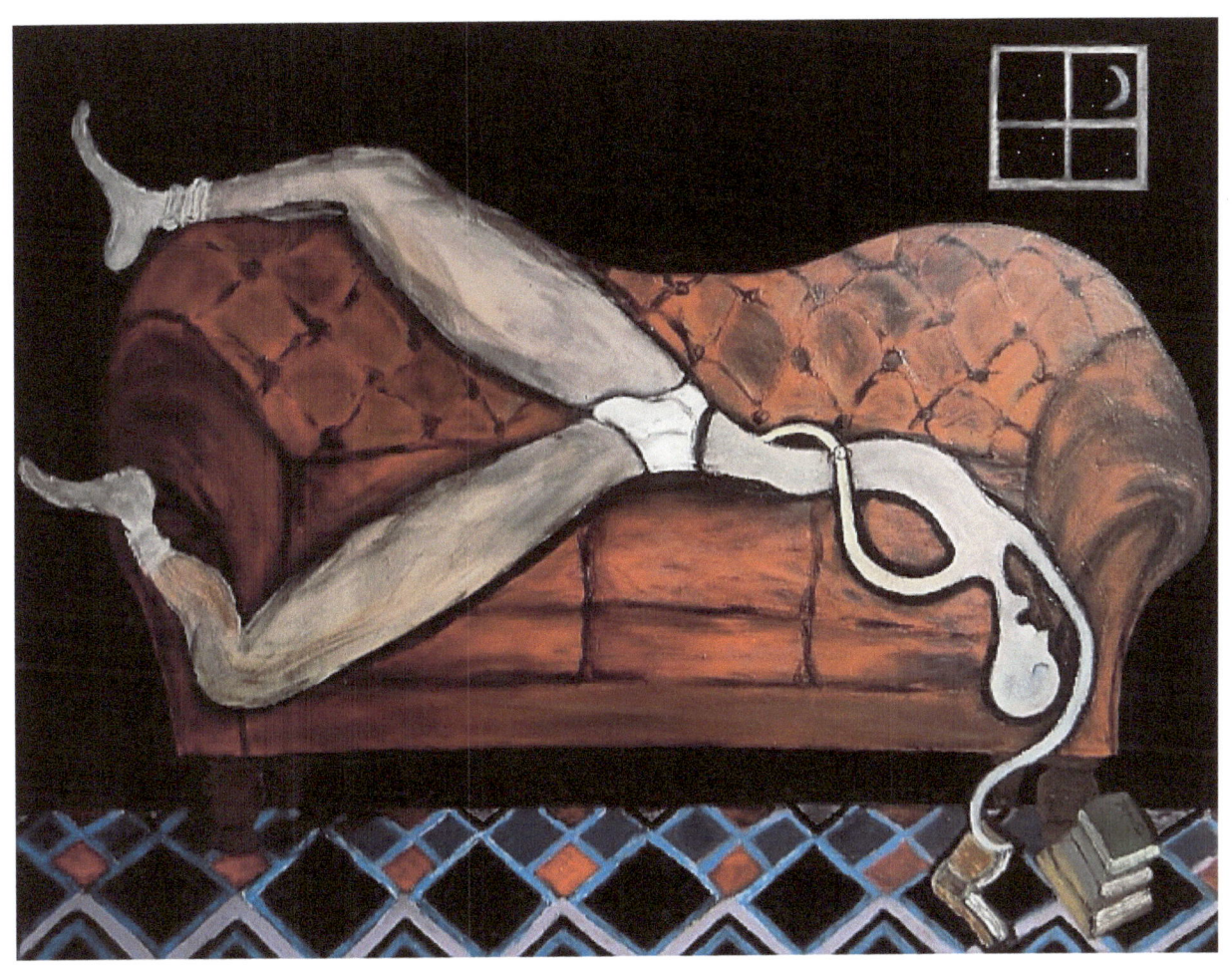

The Sprawl | Oil on canvas | 40 x 30 in.

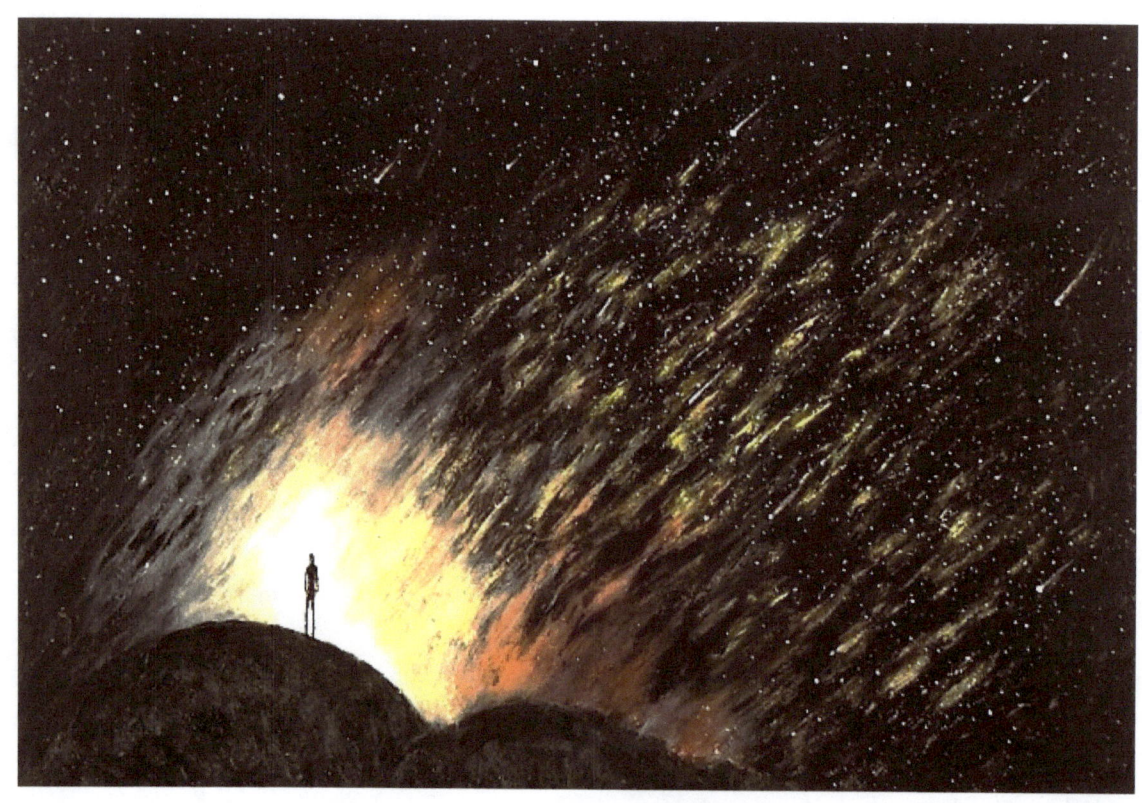

Pondering Existence | Oil on canvas | 36 x 24 in.

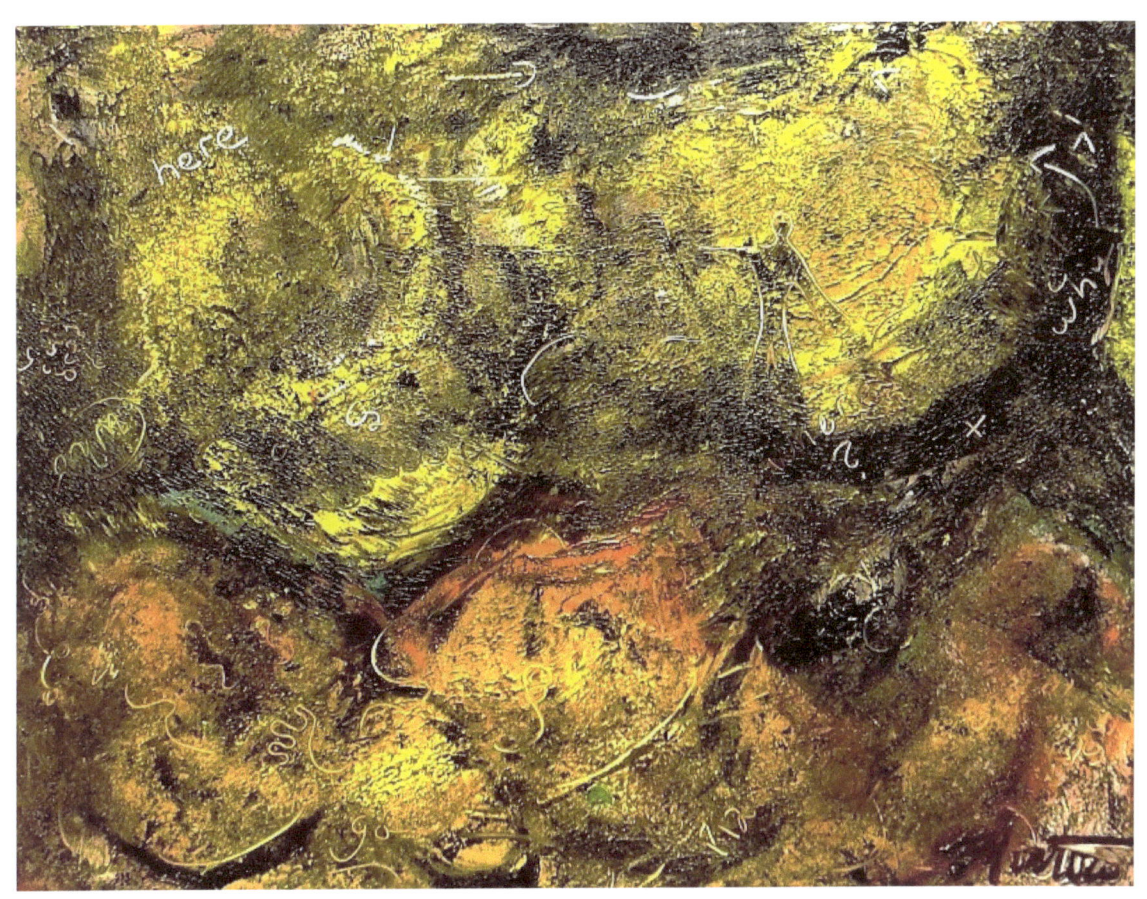

Perpetual Confusion | Oil on canvas | 36 x 30 in.

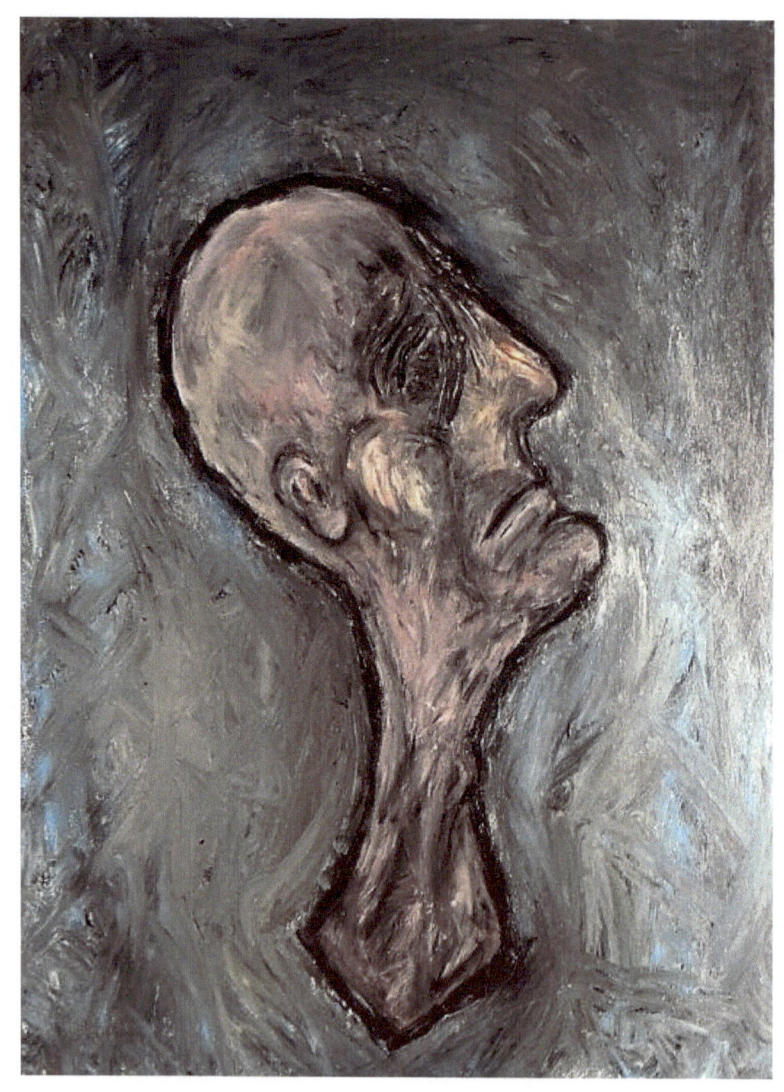

The Man | Oil on canvas | 30 x 40 in.

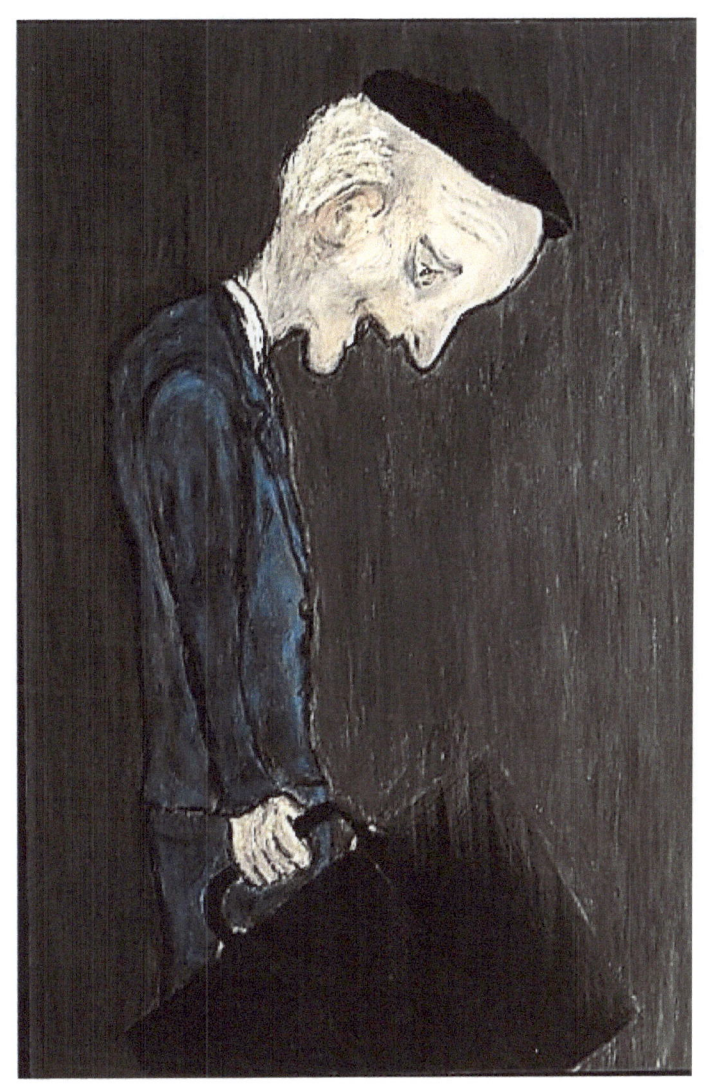

The Old Man | Oil on canvas | 24 x 36 in.

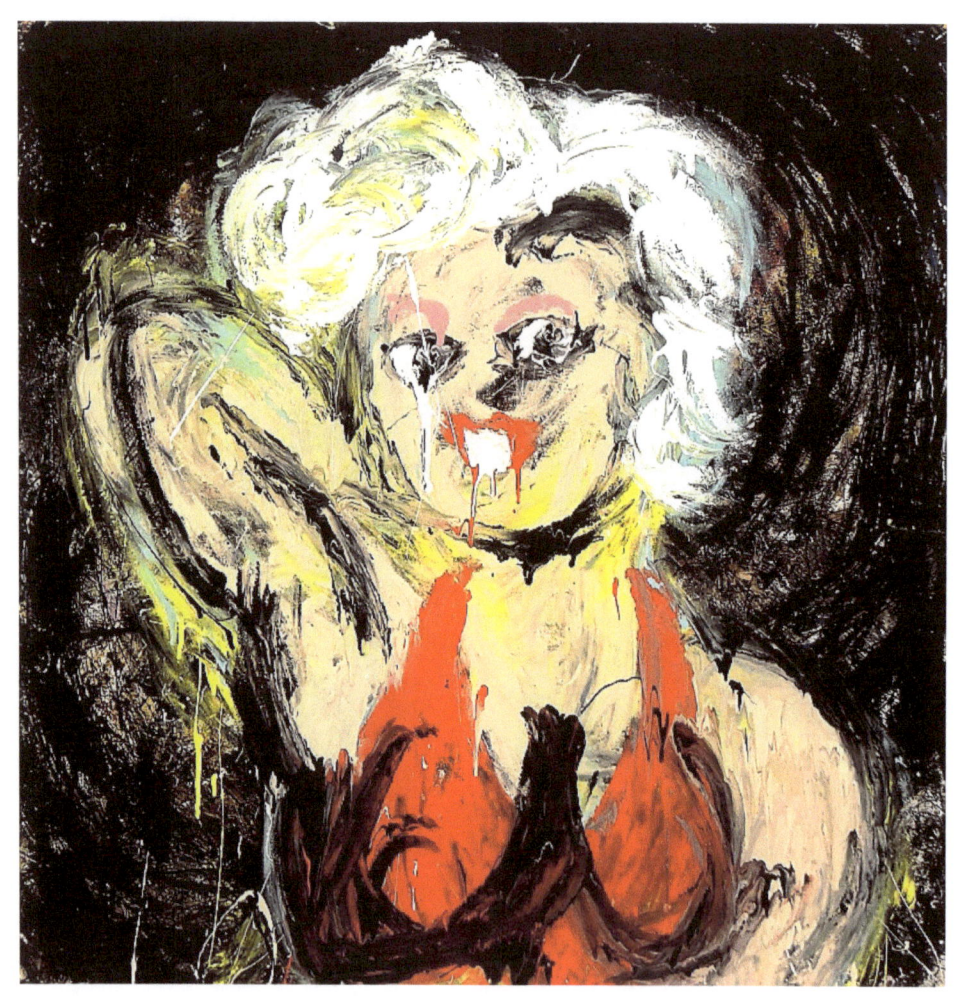

Marilyn | Oil on canvas | 36 x 36 in.

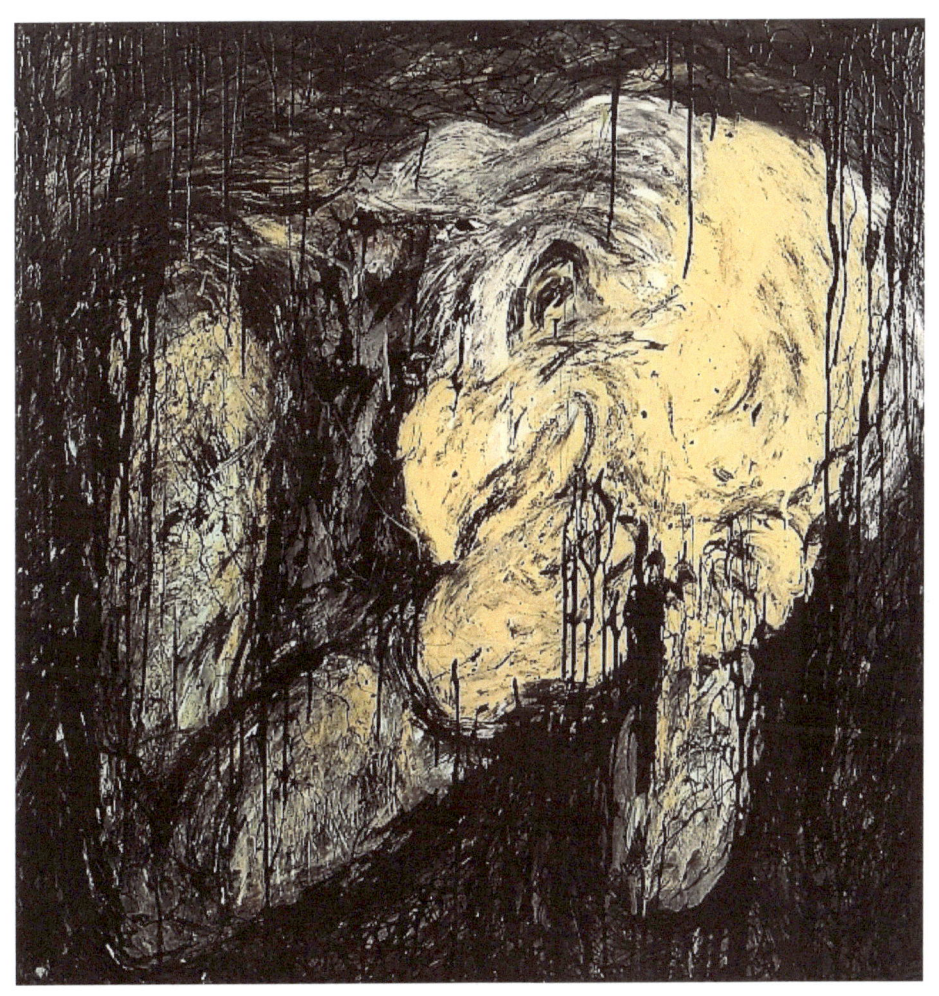

Vincent | Oil on canvas | 40 x 40 in.

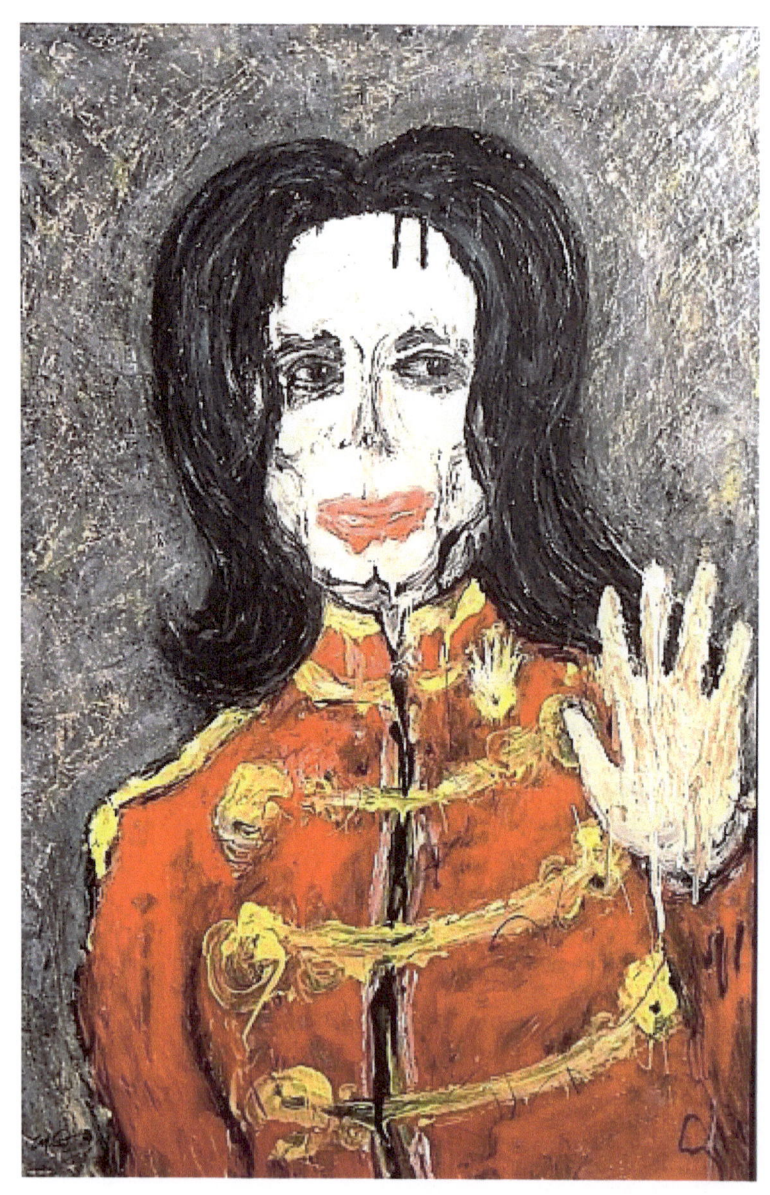

Michael | Oil on canvas | 24 x 36 in.

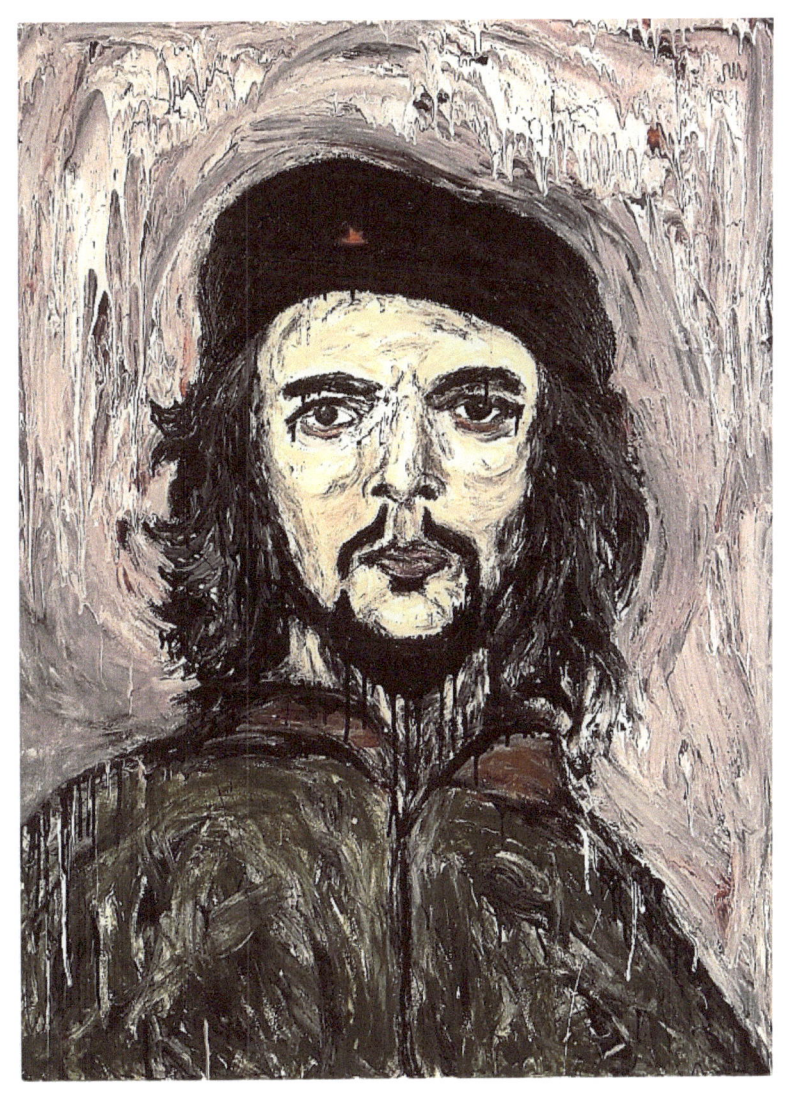

Che | Oil on canvas | 36 x 48 in.

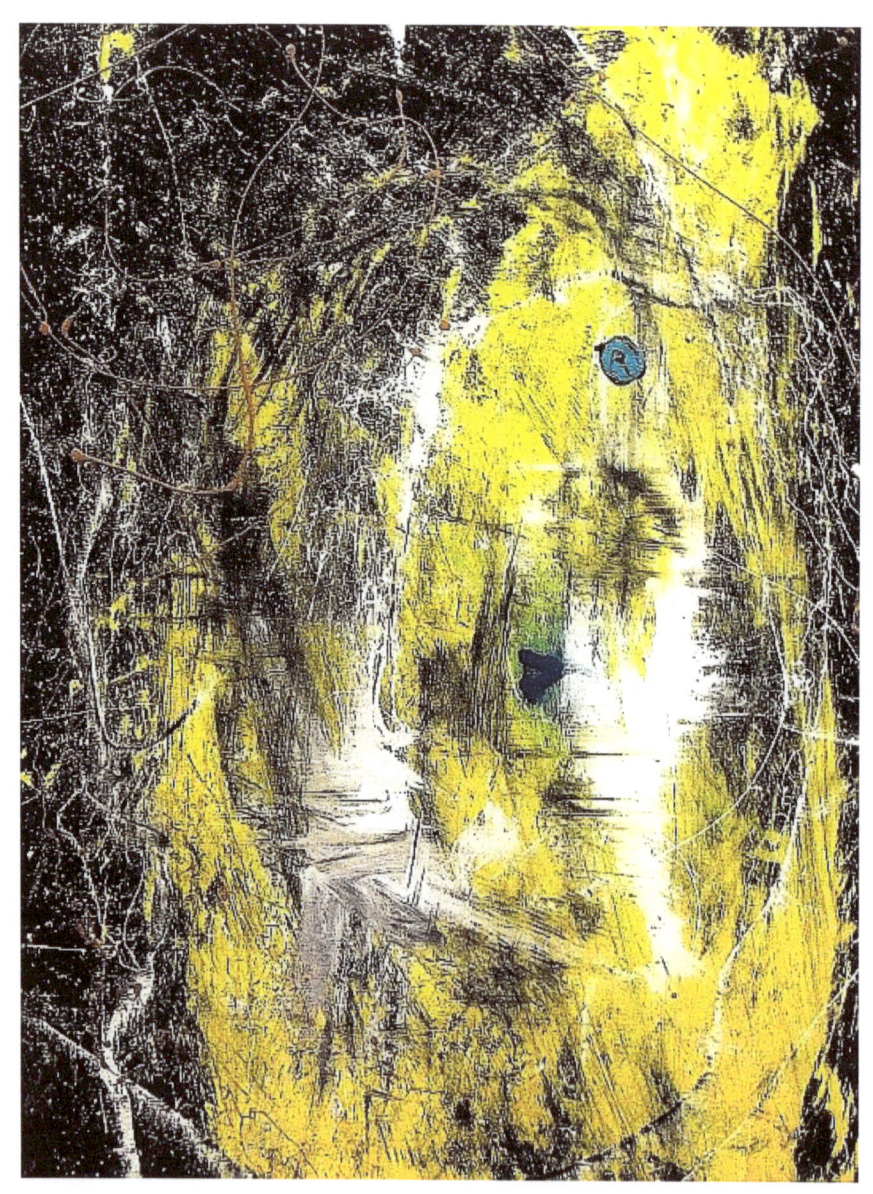

Conception | Oil on canvas | 30 x 40 in.

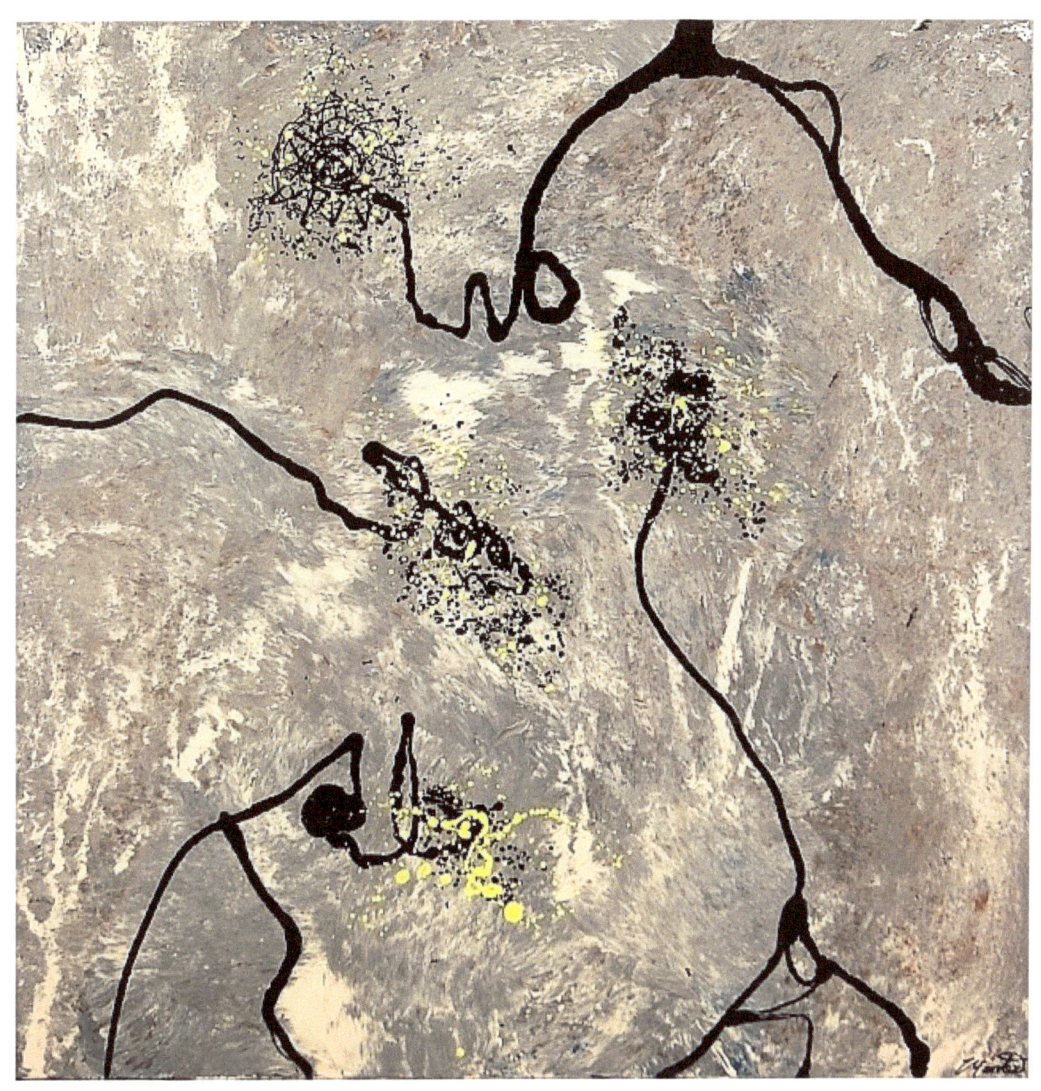

Strange Occurrences | Oil on canvas | 40 x 40 in.

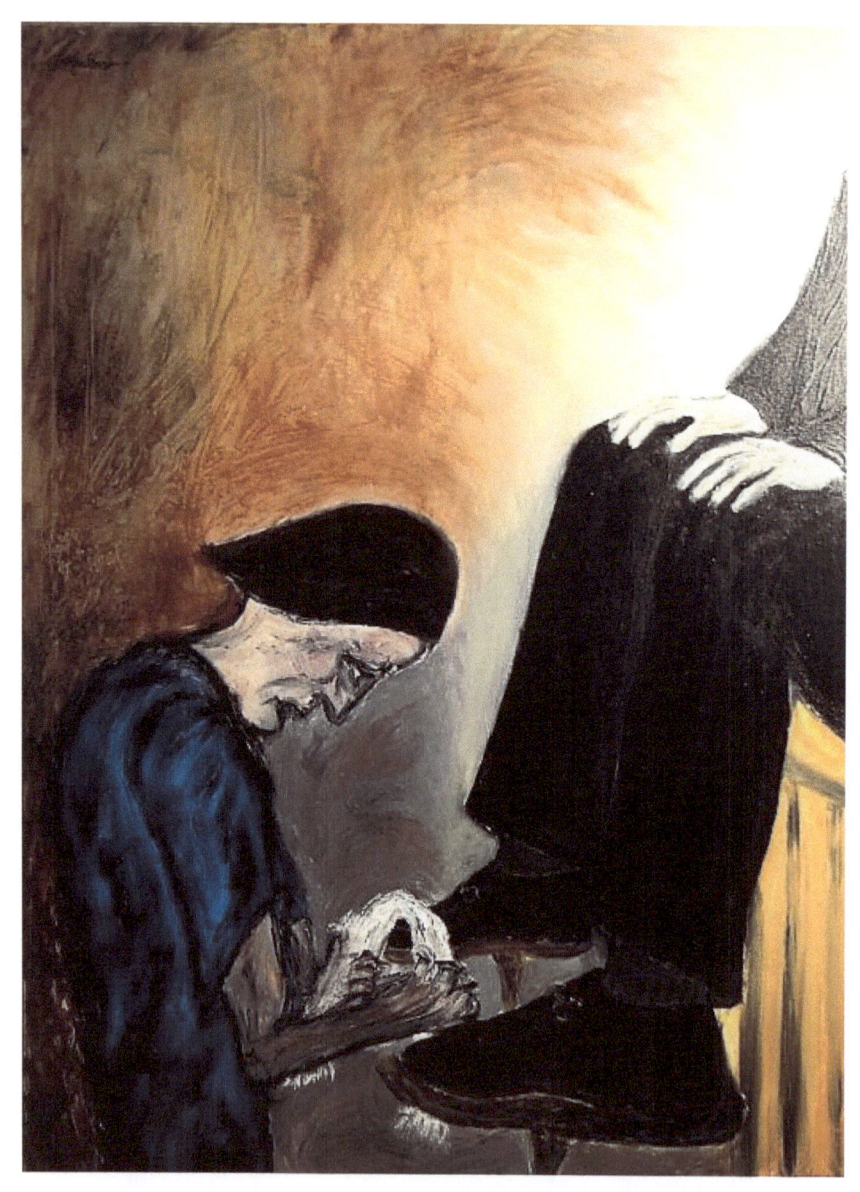

The Shoe Shiner | Oil on canvas | 30 x 40 in.

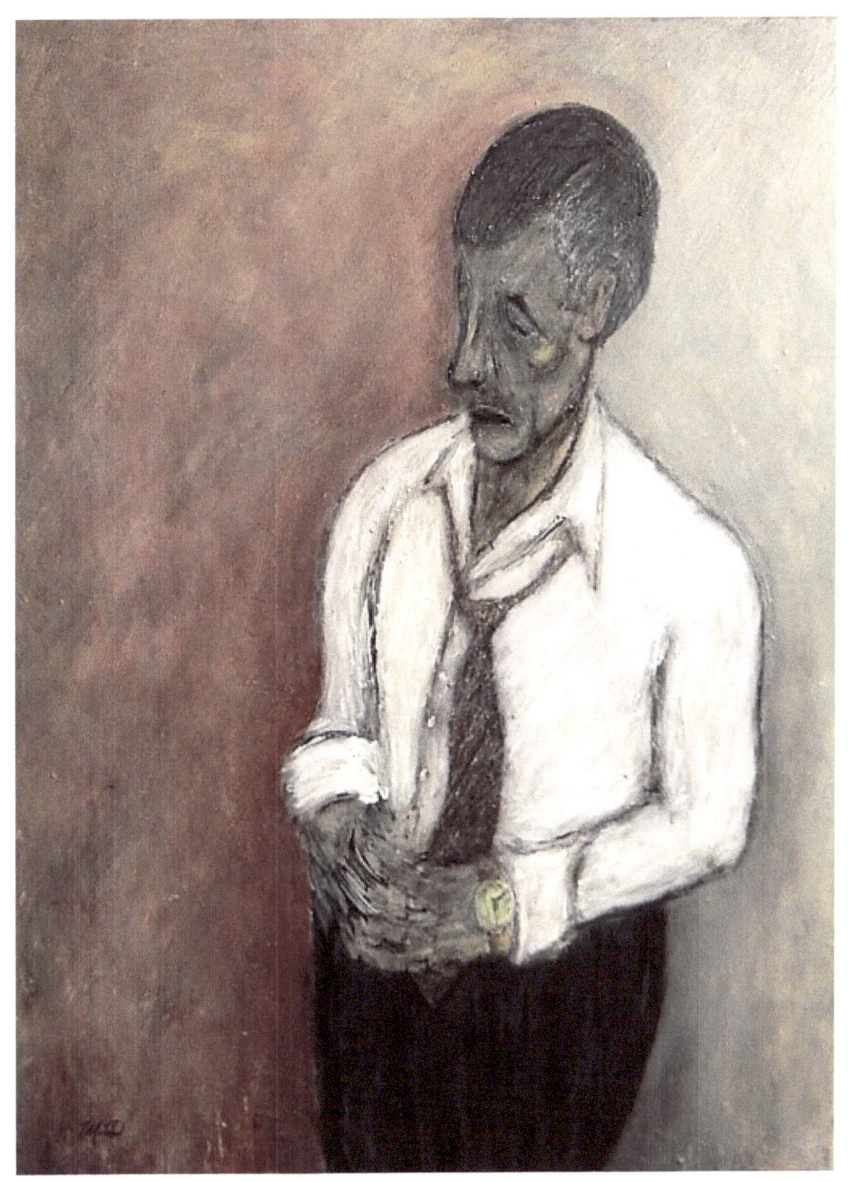

Time and Money | Oil on canvas | 30 x 40 in.

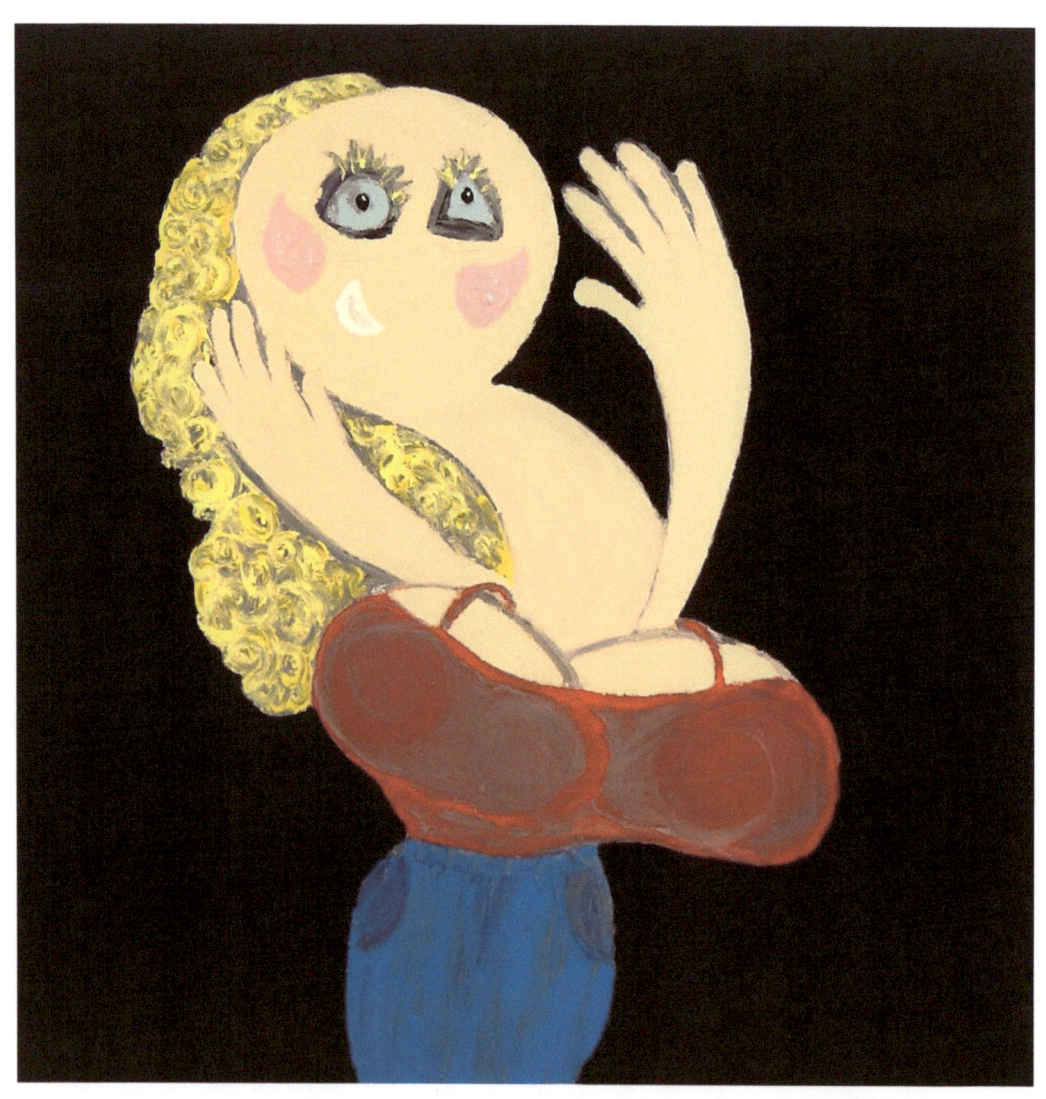

American Woman | Oil on canvas | 40 x 40 in.

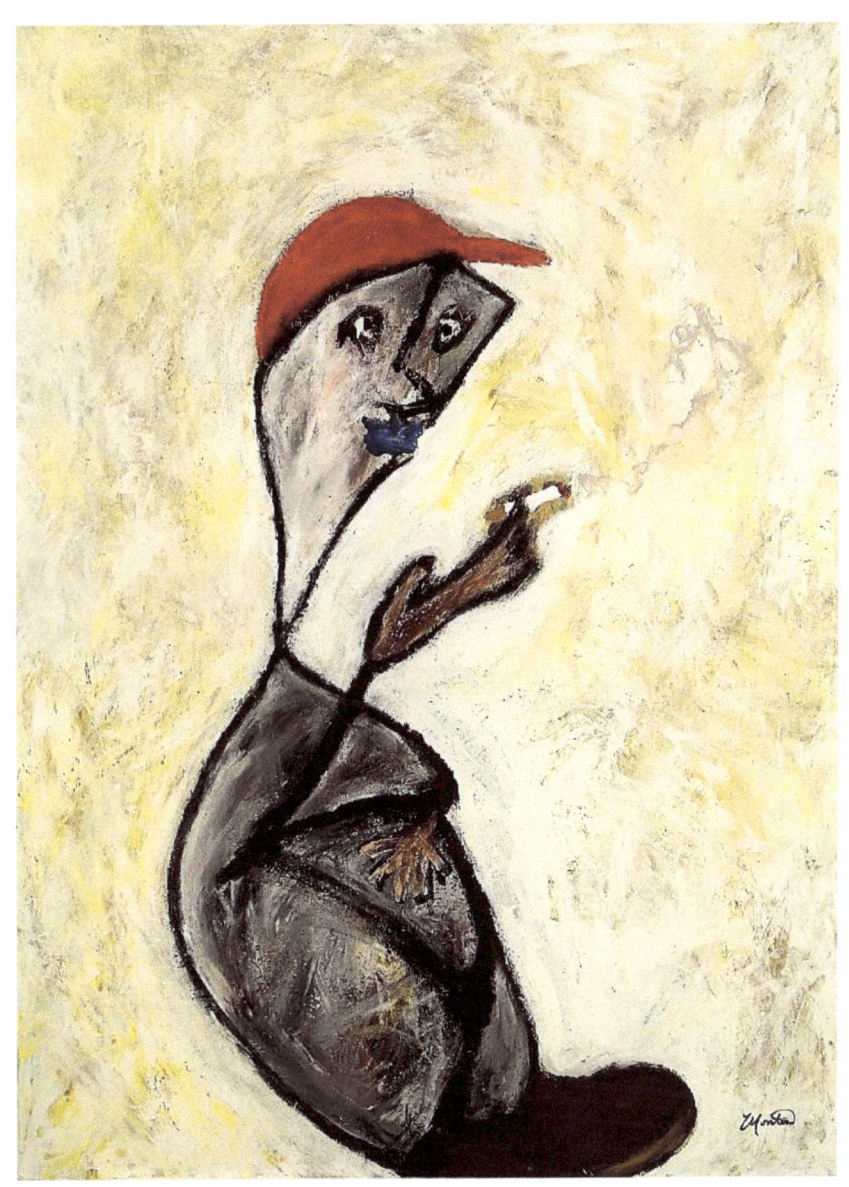

The Smoker | Oil on canvas | 30 x 40 in.

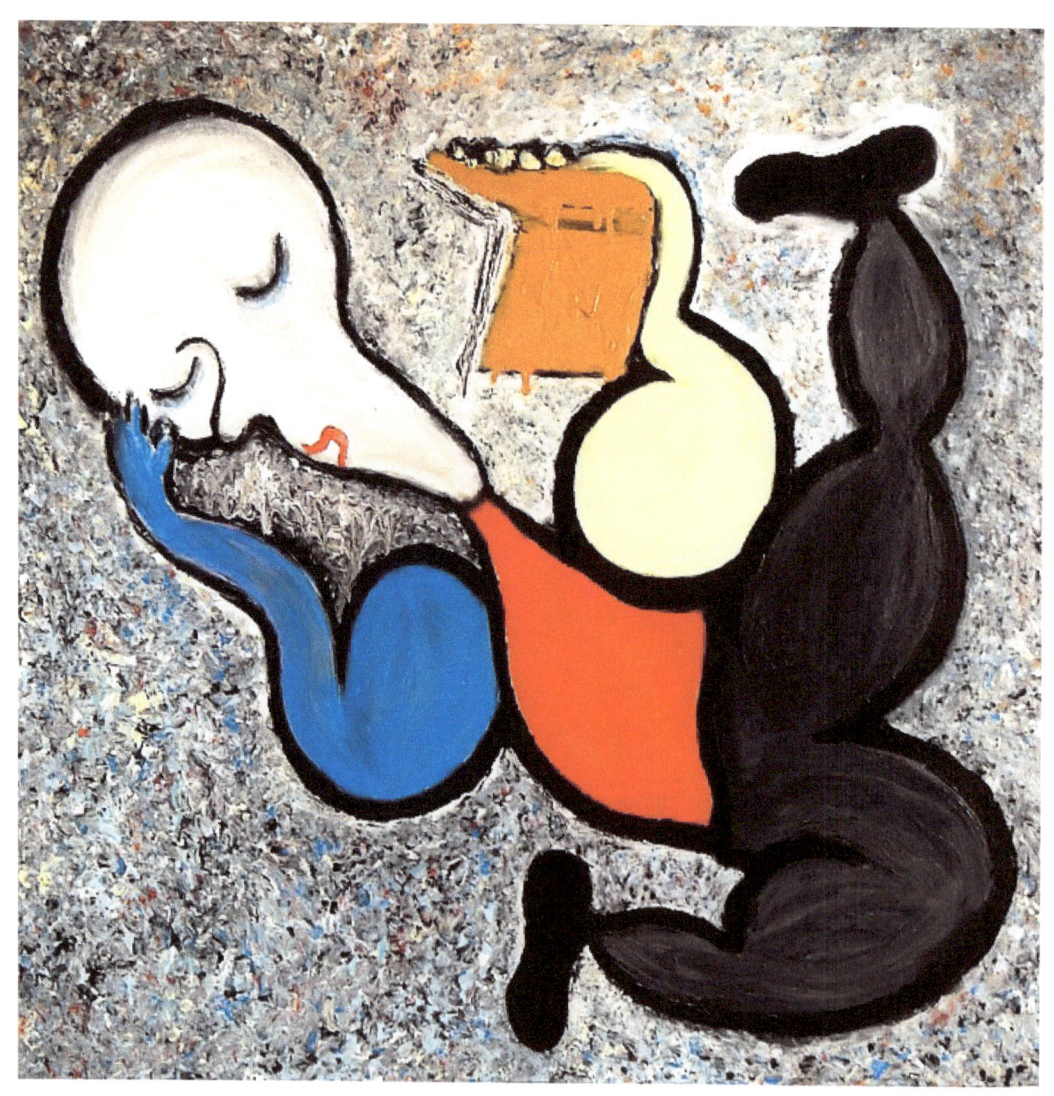

The Reader | Oil on canvas | 36 x 36 in.

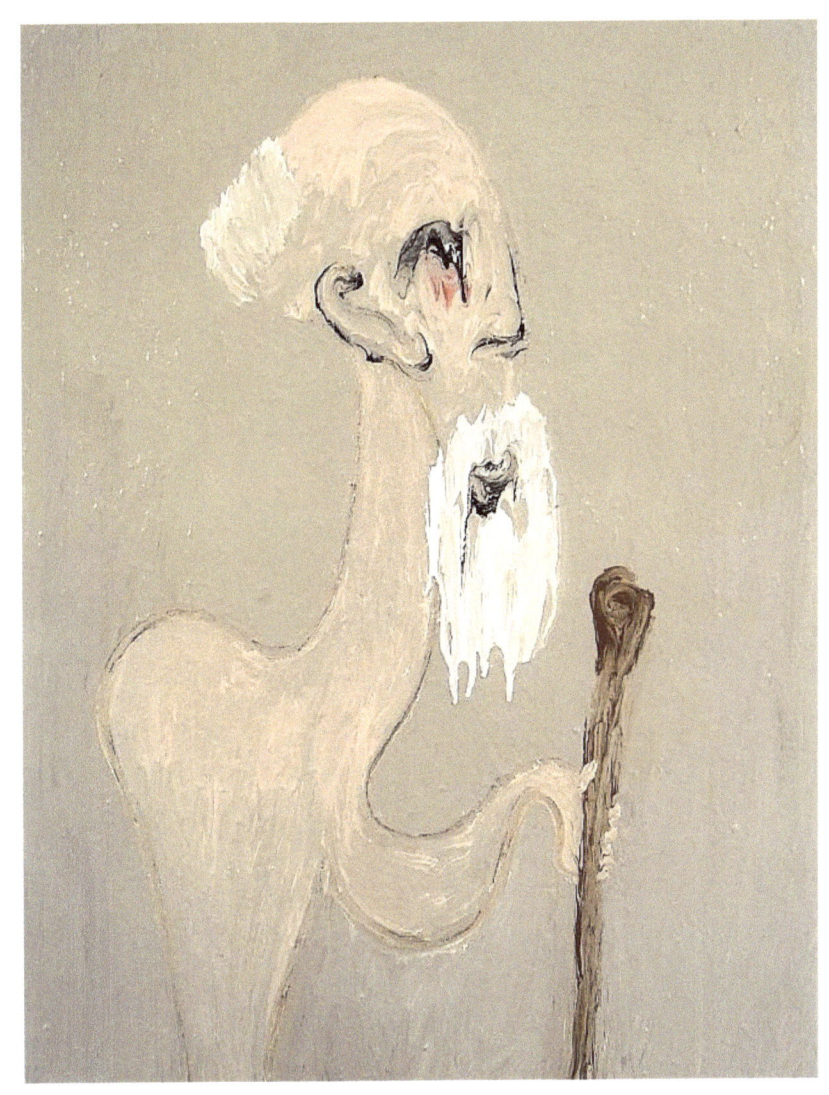

Old Man with a Cane | Oil on canvas | 26 x 30 in.

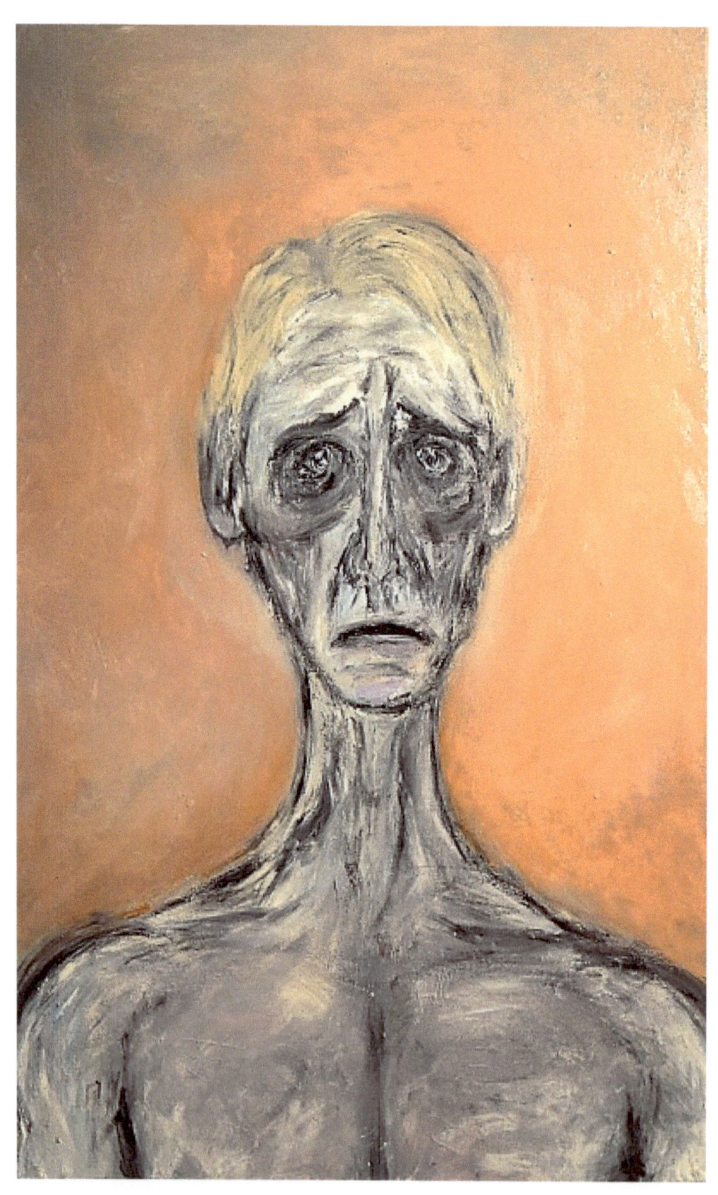

Shame | Oil on canvas | 24 x 36 in.

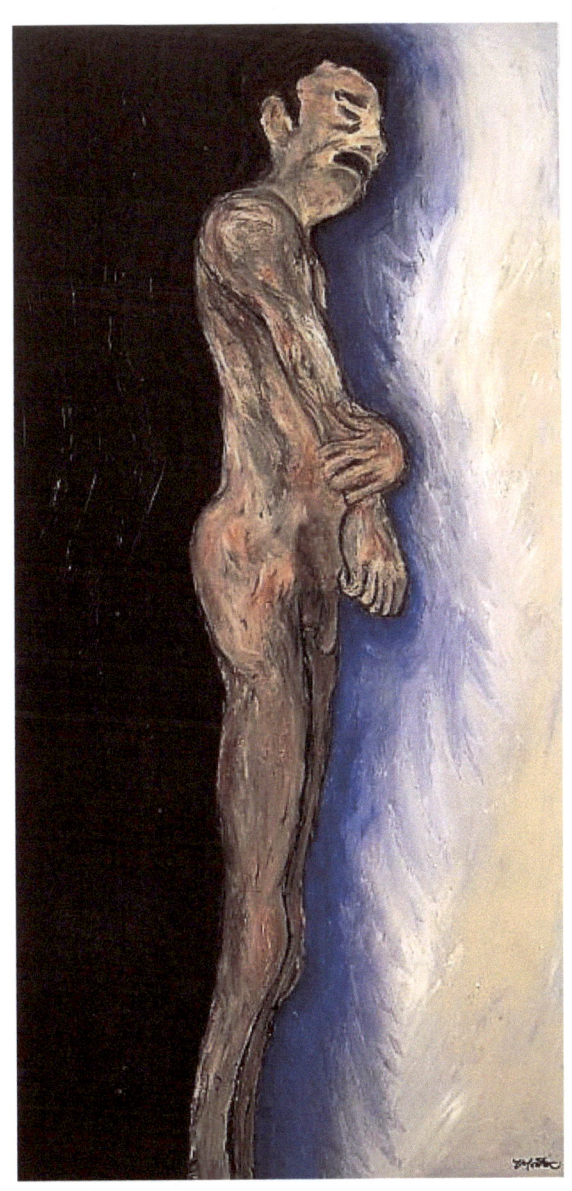

Shame II | Oil on canvas | 20 x 42 in

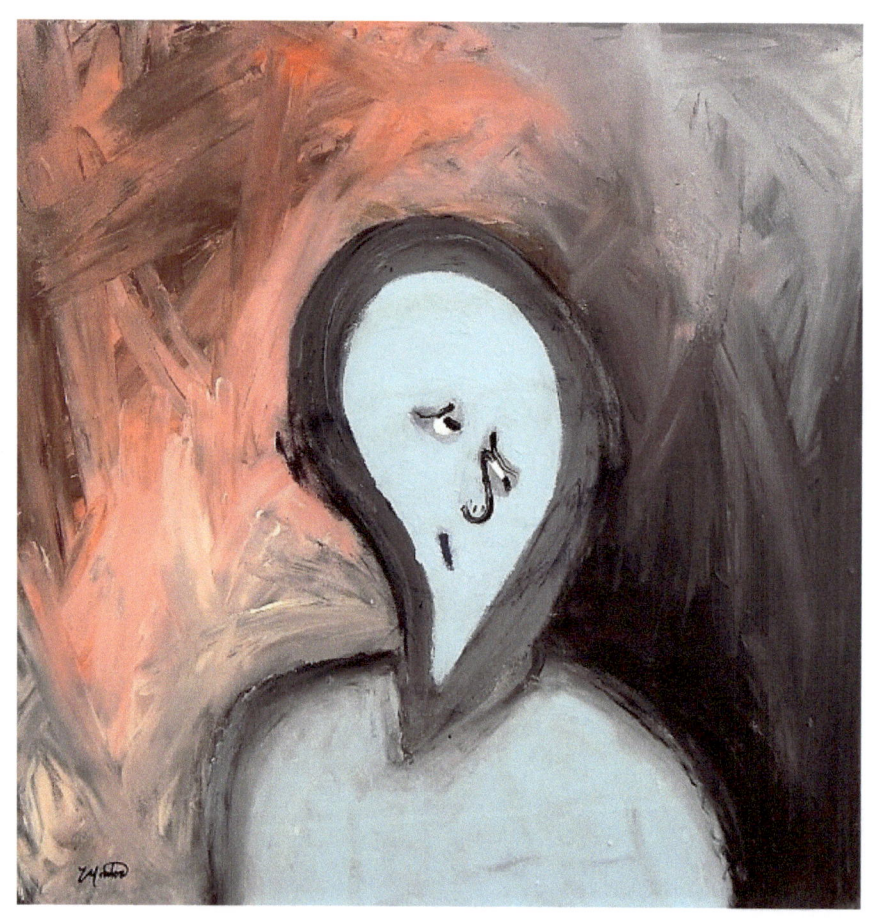

The Sad Figure | Oil on canvas | 24 x 24 in.

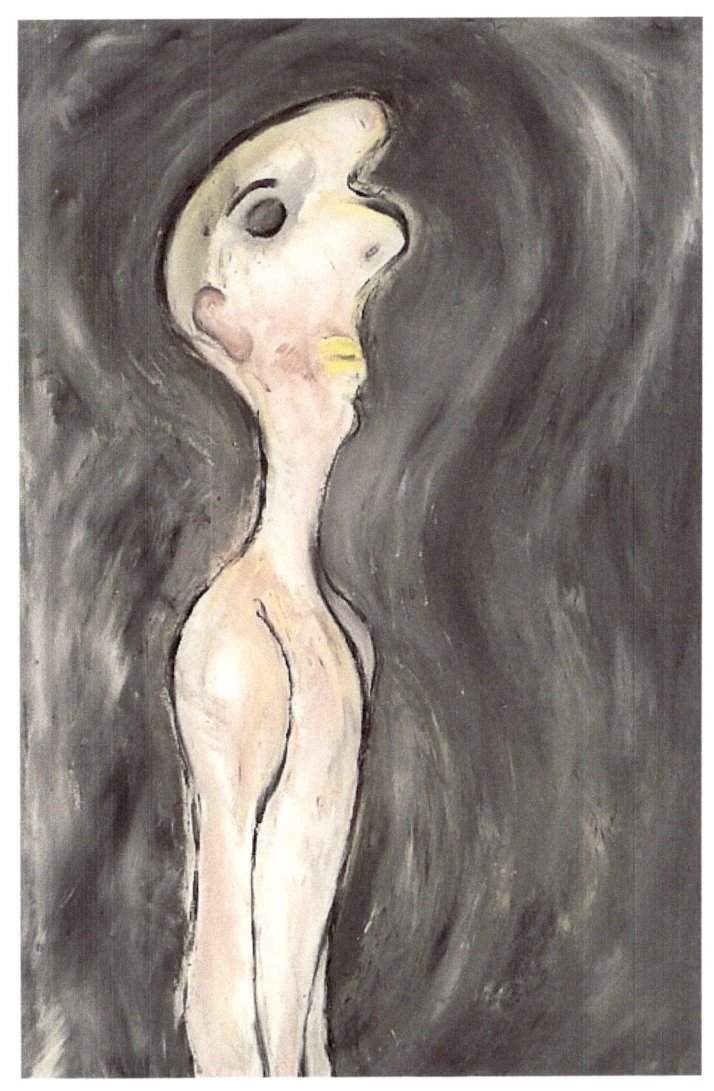

Sleepwalker | Oil on canvas | 28 x 38 in.

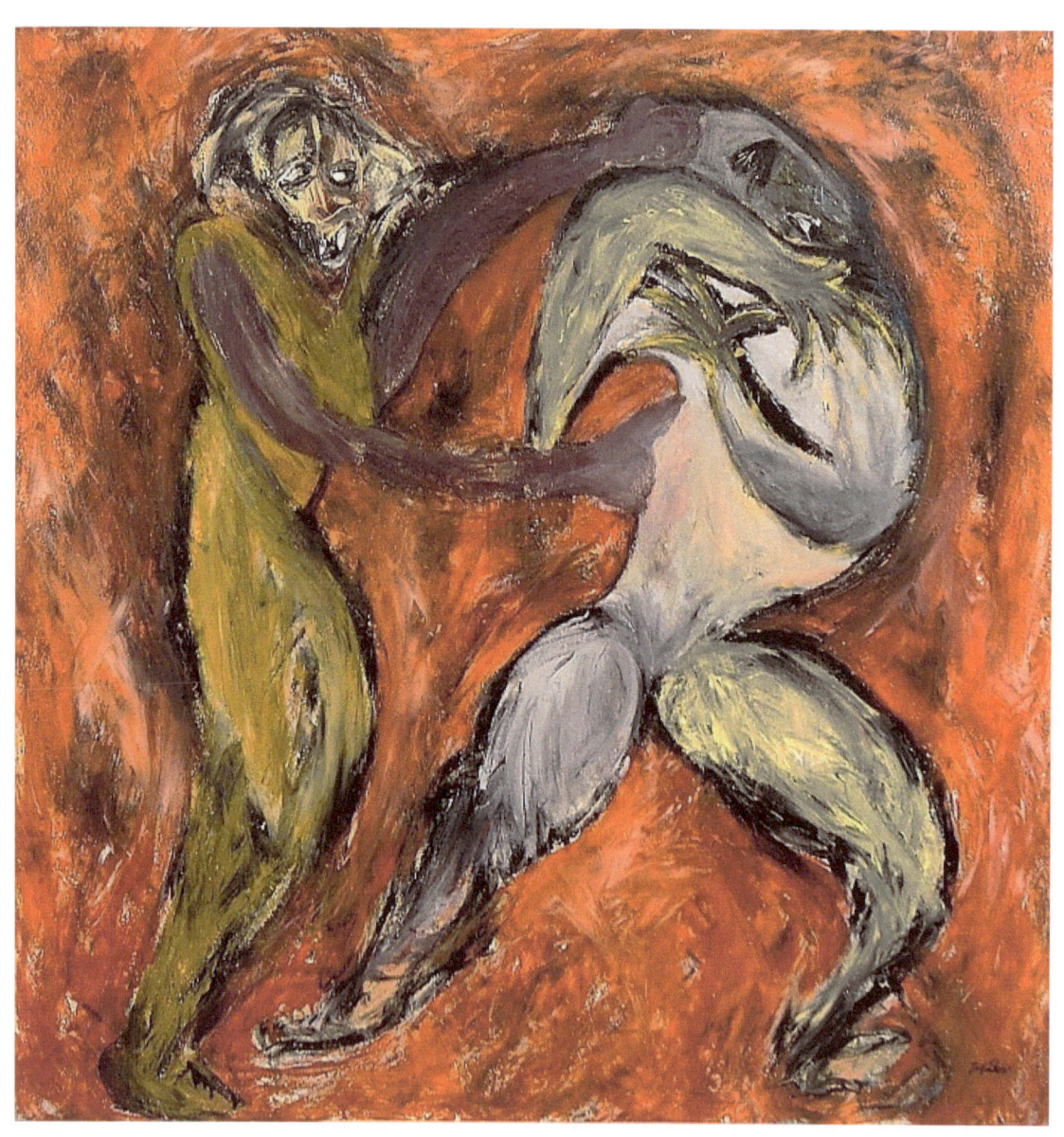

The Brawl | Oil on canvas | 48 x 48 in.

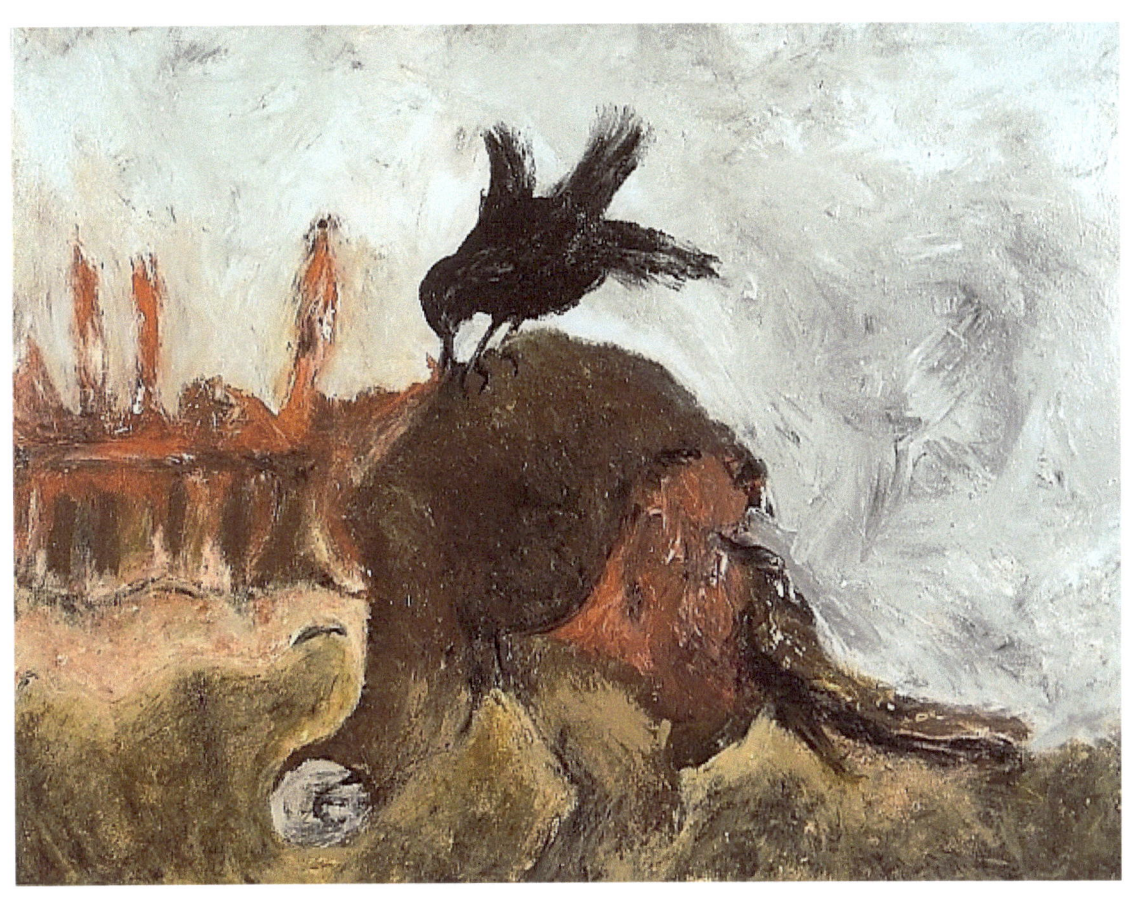

Crow Eating Carcass | Oil on canvas | 48 x 36 in.

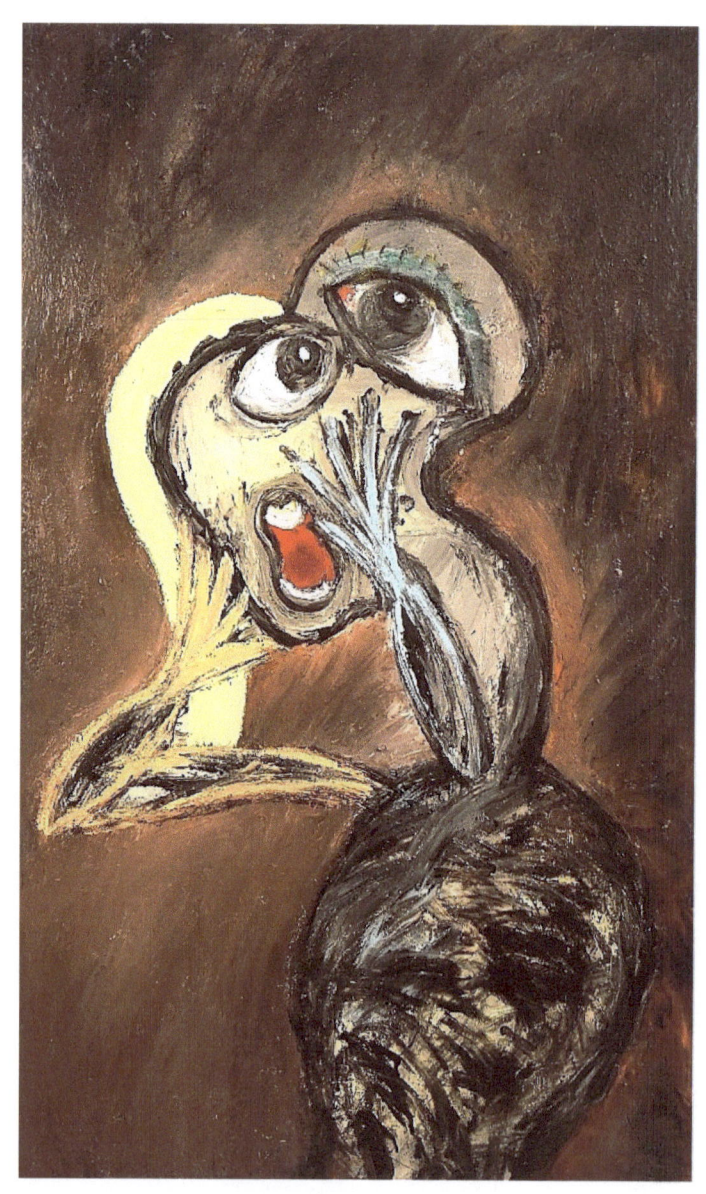

Woman in Terror | Oil on canvas | 30 x 48 in.

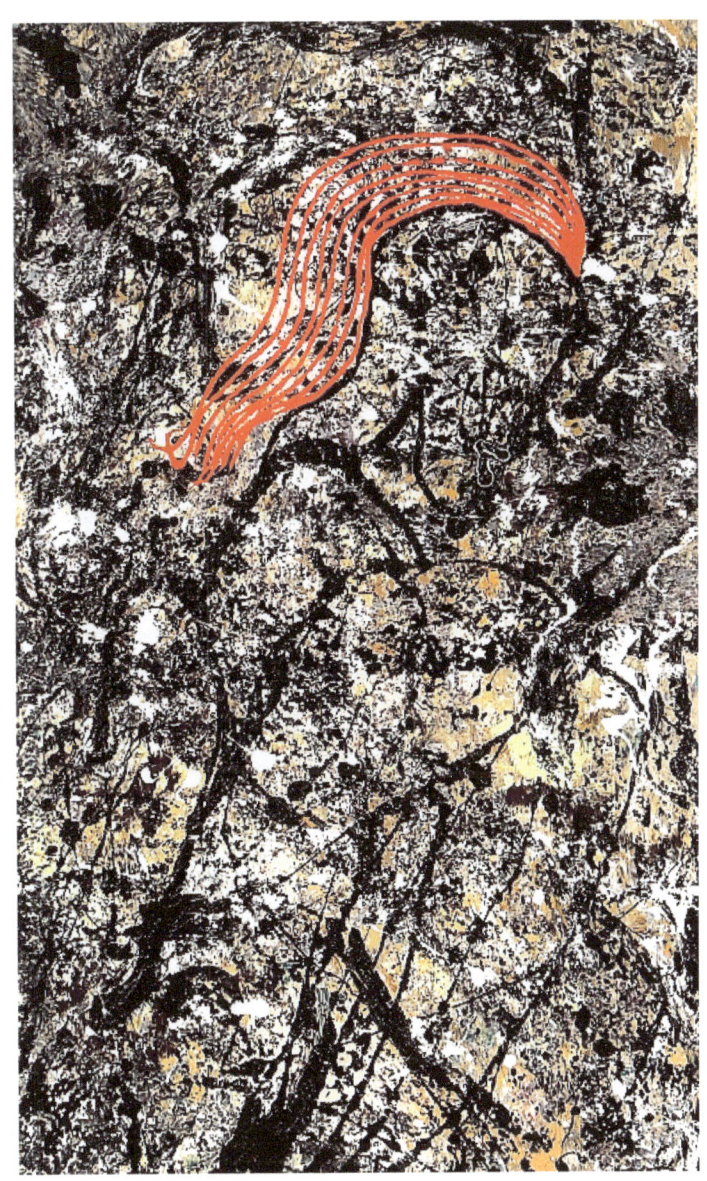

Figure | Oil on canvas | 30 x 48 in.

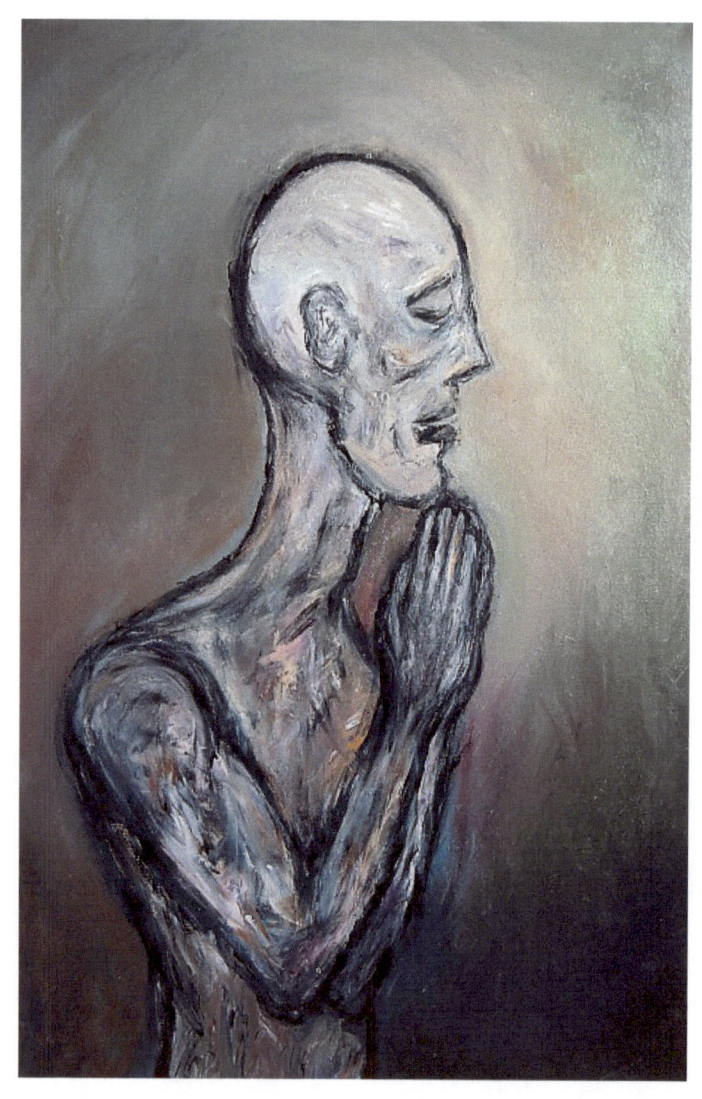

The Yearning | Oil on canvas | 24 x 36 in.

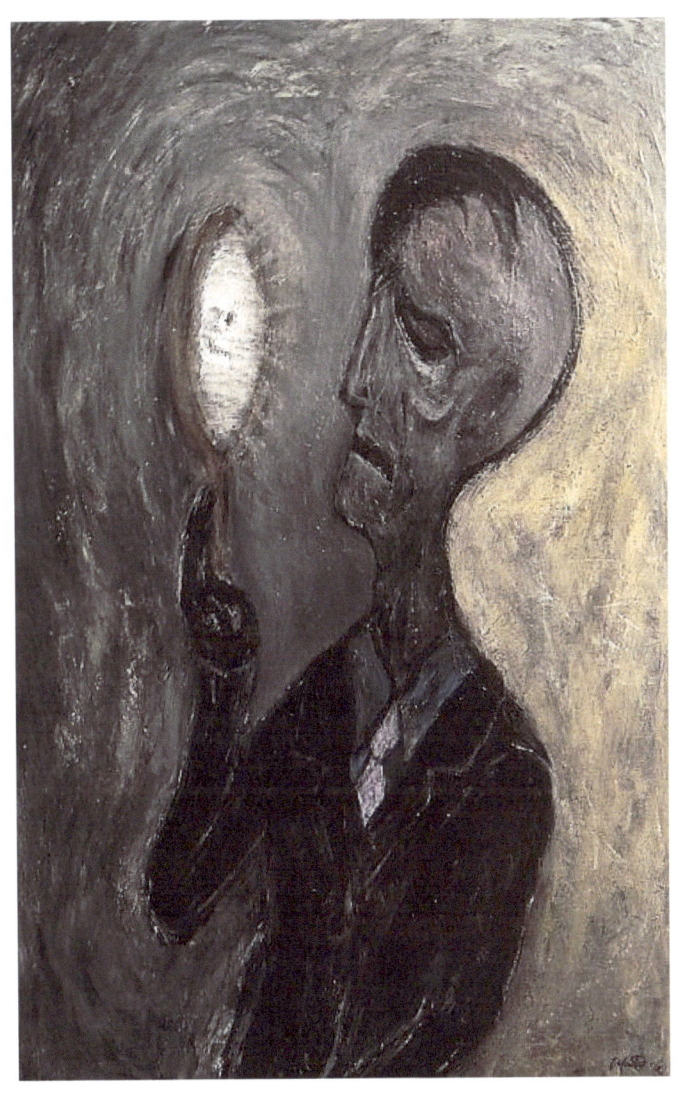

The Mirror | Oil on canvas | 24 x 36 in.

Acknowledgements

Author

David Leonard is an arts writer with a degree in English Literature & Creative Writing from the University of New Orleans. He currently works and lives in Baton Rouge. He has worked closely in the past with Montero to produce a catalogue that is both an accurate and intimate assessment of his work.

All personal and painting images courtesy of the artist Matthew Montero © 2013.

www.ingramcontent.com/pod-product-compliance
Lightning Source LLC
Chambersburg PA
CBHW051053180526
45172CB00002B/624